YESTERDAY IS FOREVER

Nostalgia and Pixar Animation Studios

JOSH SPIEGEL

The Critical Press
Philadelphia

Publisher's Cataloging-in-Publication Data
Spiegel, Josh
Yesterday is forever : nostalgia and Pixar Animation Studios / Josh Spiegel.
pages cm
LCCN 2015953924
ISBN 978-1-941629-23-9 (hbk.)
ISBN 978-1-941629-22-2 (electronic bk. text)

1. Pixar films. 2. Film criticism. I. Title.

10 9 8 7 6 5 4 3 2 1

CONTENTS

ACKNOWLEDGEMENTS

In the summer of 2011, after years of listening to various entertainment podcasts, I impulsively decided to start one of my own focusing on the movies of the Walt Disney Company. Because of that show, *Mousterpiece Cinema*, I pushed myself to once again write on film, a passion I'd allowed to lie dormant for too long. *Mousterpiece Cinema* casts a wider net than just the films of Pixar Animation Studios, but if not for that show and my general commitment to its continued existence when it was a solo venture, this book wouldn't exist.

So let me thank Ricky da Conceição and Sam Fragoso, the benevolent overlords of *Sound on Sight* and *Movie Mezzanine*, respectively. Both Ricky and Sam have, at different points since 2011, taken a chance on me as a writer and podcaster. They not only encouraged me in both areas, but allowed me to grow in ways I hadn't imagined. I also want to thank the podcast's co-hosts, Gabe Bucsko and the late Michael Ryan. I'm lucky to have had them as friends and colleagues (and, in Gabe's case, a helpful source of advice as I worked on this text).

Speaking of taking chances, here's a hearty thanks to my publisher, Tom Elrod. What Tom is doing at the Critical Press is vital to the future of film criticism; having a platform to write this book is an extraordinary gift I'm still amazed by.

My parents, bless them, aren't as impassioned about cinema as I am, but their love and support—as well as their tolerance for my childhood desire to watch every movie (*every movie*) I'd see in

theaters at least twice—has kept me going all these years. They may not be as intrigued by aspect ratios, independent cinema, or the deeper meaning of Disney Renaissance films; however, they encouraged me to follow my passion from a young age.

Finally, this book would not exist if I were not surrounded by love at home from my wife, Elyse, and our infant son, Oliver. Elyse is unquestionably the most supportive, loving, and altogether patient person I've been lucky enough to meet. I'm incredibly blessed to have her in my life at all. Oliver: as I write these words, you're too young to know their meaning, but I dedicate this work to you; let this book stand as a symbol of what you can accomplish as you grow up in a new world.

INTRODUCTION

It's fitting that *Toy Story* opens with the same image as the final frame of *Toy Story 3*: a picture-perfect blue sky dotted with carefully placed, fluffy clouds. These soothing designs are computer-generated facsimiles, but the former is a facsimile of a facsimile; it's the comforting wallpaper that lines the bedroom of a little boy named Andy Davis, who lives in a small town of indeterminate origin, a true Anytown, USA. The latter image is closer to an actual skyline, greeting the teenaged Andy as he drives off to college from that unknown municipality and out of the lives of the toys with whom he populated his imagination for over a decade.

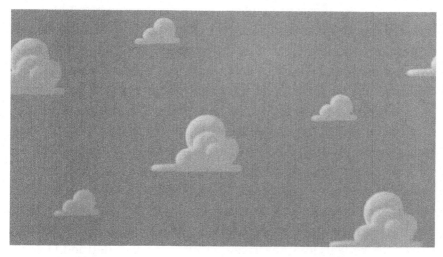

The blue-sky wallpaper in Andy Davis's bedroom is the first image we see in Toy Story (1995), the first fully computer-animated feature ever made.

As the series opens, the six-year-old Andy, a suburban Christopher Robin, proves in the confines of his tiny room—brimming to the rafters with plush animals, board games, action figures, and other toys—that his world of make-believe is limitless. As the third feature in the franchise closes, Andy ventures into the known unknown of the real world, wished an emotional goodbye by the surviving plastic and stuffed figures of his youth. In this moment, they have reached the same conclusion he did as a boy: anything is possible. These fully fleshed-out characters, who display a vast well of human emotions over a trio of films, come to appreciate that life is the very opposite of the mundane and predictable drudgery they assumed it was.

The *Toy Story* series, spanning fifteen years, is the greatest, most purely American trilogy of the modern age—an encapsulation of the objects and caricatures that filled the imagination of the children of the twentieth century. Its existence is a near-impossible feat, both in its creative triumphs and its three respective production histories. The series is based on a rock-solid foundation of sincere nostalgia, a fondness for the past expressed less to sell toys than to simply marvel at the joy of youth. The nostalgia of modern popular culture is in part inspired by films like *Toy Story*, but most creators use nostalgia cynically. Pixar's filmmakers, wisely, treat it as a valuable emotional reaction, as worthwhile as the desire to laugh or cry or otherwise empathize.

The image of the blue sky throughout the series, welcoming us and bidding farewell, is inherent to the ever-flourishing success of the Walt Disney Company since the 1930s. Walt Disney Imagineering is built on the concept of "blue-sky" speculation, in which Imagineers conjure up ideas at the outset with no limitations on money or resources. Though Pixar Animation Studios was first an outside company lured in by Jeffrey Katzenberg and Michael Eisner during their time at the Walt Disney Company, the studio's ideals are inextricably linked to what defined Disney, the company, and Disney, the man, from the 1930s through the 1960s. Pixar's methodology is built on blue-sky speculation.

It's no wonder that Pixar's films and characters have become so influential, to Disney's own animation department as well as to the rest of Hollywood, in the same way that *Snow White and the Seven Dwarfs, Fantasia, Pinocchio, Dumbo,* and *Bambi* were during Disney's first golden age. You can draw a straight line from films like *Toy Story* and *The Incredibles* to *Wreck-It Ralph* and *Frozen*; the latter two films were heavily inspired by Pixar's output. More specifically, the baton with which Walt Disney Animation Studios ran in the late 1980s as the so-called Disney Renaissance kicked off, beginning with *The Little Mermaid,* was, in effect, unintentionally passed to Pixar in 1995 with the first *Toy Story.* Since then, Disney and their mainstream competitors have all struggled to catch up to the industry's new standard-bearer.

Pixar's dominance started with the blue-sky notion that its employees could make anything happen on a computer—more so than would ever be accomplished with pencil and paper. The *Toy Story* trilogy should be held up as an exemplar of how the creative process doesn't have to be driven by a single person's journey to be satisfying, and that revision in the process can sometimes lead to a more positive outcome. These films prove the collective auteurism at play within Pixar and the flexibility of the blue sky.

Each *Toy Story* film was created under immense stress and tension, as well as under incredible time constraints. The first film's script was completely rewritten in a two-week period at the end of 1993, lest the filmmakers' ties with Disney be severed wholly; the second was initially designed for a direct-to-video release, and was then reconceived and wholly overhauled throughout 1999, giving the filmmakers just nine months to redo the project; the third was nearly crafted by an outside group, during the grim period in the mid-2000s when Pixar nearly became a cinematic free agent, and Disney grasped even more desperately for future computer-animation supremacy. That these three films exist in

their current form is a minor miracle; that they are among the most emotional, insightful, clever, and humane films of the past twenty years, live-action or animated, is a major one.

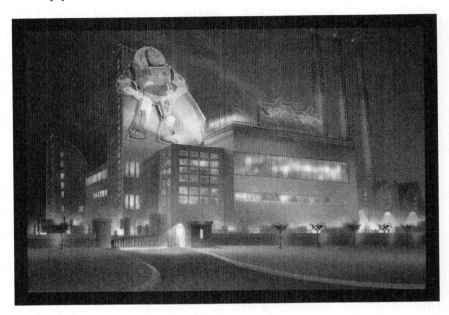

This piece of concept art from the now-defunct Circle 7 Animation displays the original take on Toy Story 3, had Disney broken ties with Pixar but kept the rights to the studio's prior films and related sequels.

However, most of Pixar's films rely on a fascinating dichotomy worth exploring in depth. From the very first, each of the studio's films has been defined by both groundbreaking technology and a generally innovative visual spirit. Audiences have come to expect—occasionally to their detriment or to the studio's—that a Pixar film will boast stunningly photorealistic animation as much as it may boast memorable characters, thrilling set pieces, or outrageous humor. Since 1995, Pixar Animation Studios has represented and championed the future of the medium, but in doing so, their filmmakers have also consistently reached back into their pasts.

Pixar's nostalgia for an unjustly forgotten time—or, sometimes, one that's just an idyllic fantasy—permeates many of their films. The messages in each entry of the *Toy Story* trilogy are thus mirrored in other Pixar films; *Toy Story* and *Cars* share a kinship beyond their director, *Toy Story 2* and *Up* relate similarly to the destructive force of nostalgia, and *Toy Story 3* and *Monsters University* reflect their newer directors' struggle to follow in their idols' footsteps while being distinctive in the middle of a franchise. Even Pixar's newest film, Pete Docter's *Inside Out*, is obsessed with tracking a child's shift from adolescence to the onset of adult maturity, and the inherent tragedy of leaving pure joy behind. These disparate worlds are united by the notion that to forget the good old days, even if those days exist entirely in the mind's eye, would be a greater offense than abandonment or heartbreak.

And just as Pixar set the standard for other animation studios visually, so too have they creatively pushed Walt Disney Animation Studios to look fondly upon their collective youth—to the worlds of princesses, videogame characters, and long-forgotten stuffed animals—for purportedly new stories. *Tangled*, *Winnie the Pooh*, *Wreck-It Ralph*, and *Frozen* may appear wildly different from each other at first glance, but their respective charms and flaws are borne from their makers' attempts to ape Pixar and look back to the past, as well as the desire to make untold billions from myriad merchandising opportunities.

The key quote that encapsulates the balance between Pixar's pioneering technological spirit and its backwards-looking creative aims, appropriately, refers to Walt Disney's crown jewel: Disneyland. It took Walt Disney Imagineering until the last few years to truly embrace Pixar's worlds for its theme parks; now, you can't go to either Disneyland or Walt Disney World without seeing characters like Buzz Lightyear, Mike Wazowski, and Lightning McQueen in person or in attractions, unless you actively avoid them. But these words were spoken before such characters were even a wisp of an idea, back in the days when

John Lasseter was just a skipper on the Jungle Cruise ride in Anaheim. Spoken by the original "Voice of Disneyland," announcer Jack Wagner, the quote is as follows: "Disneyland is a first, an original. Since the day it opened in 1955, more than a hundred million people have come here from the four corners of the Earth to participate in adventures unique in all the world. *Here, tomorrow is today and yesterday is forever.*" At Pixar, as in the rest of popular culture now, the future is here and the past is infinite.

TOY STORY AND *CARS*

Andy Davis, in the first act of Toy Story 2 (1999), holds his pull-string Sheriff Woody doll, pondering what mischief he can make before heading off to cowboy camp.

"Who would want to see a movie about a little boy who plays with dolls?"[1]

When this question was posed over two decades ago by Michael Eisner, CEO of the Walt Disney Company at the time, the answer was unclear. Eisner doubted the creative and financial possibilities of a modestly budgeted film called *Toy Story*, hailing from a fledgling computer animation studio whose original purpose was to create cutting-edge software while one of its employees made animation for TV commercials and convention-set demonstrations on the side.[2] That employee was John Las-

seter; just over ten years after *Toy Story* was released nationwide in November 1995, Lasseter would become the Chief Creative Officer of Pixar Animation Studios, DisneyToon Studios, and Walt Disney Animation Studios itself.[3]

Five months later, his fourth directorial effort, *Cars*, opened and represented the first critical stumble for Pixar, despite owing just as much to his past as *Toy Story* does. Both films serve as Lasseter's affirmation that nostalgia is a healthy guiding principle for life, yet *Cars* also relies heavily on the potential for merchandising its characters to death, whereas *Toy Story*, amazingly, didn't. Thus, John Lasseter's creative peak came twenty years ago.

Lasseter's sudden and enormous success came about in no small part because he innately knew the answer to Eisner's query, even before audiences had a chance to prove him right: pretty much *everyone* would want to see a movie about a little boy who plays with dolls. In the early 1990s, Lasseter, who co-wrote and directed *Toy Story*, may not have been as confident about the prospects of a film focusing on his past, if not the past of all 1960s-era children. The characters that kids of the sixties played with didn't exist on the big screen yet, and hadn't been so successful as to spawn extensive franchises or storylines; tapping into his fellow baby boomers' memories allowed *Toy Story* to become such a massive success precisely because it hadn't been done before. The film's success has helped guide mainstream cinema towards an all-encompassing nostalgia.

Nostalgia is the renewable fuel of modern popular culture; it is an invisible perpetual motion machine. As long as there's another movie, TV show, book, comic book character, toy, or videogame on which one of us can look back fondly, it'll never run out. We often don't care if the actual experience of some piece of culture doesn't align with the memory concocted around it; innately knowing that we enjoyed something when we were children is enough to allow us to don rose-colored glasses about the quality of what we enjoyed.

Toy Story is not the true beginning of this Nostalgia Era of modern filmmaking—the sources stretch back to the 1920s—but it is an important touchstone of the period, which is somewhat ironic considering its intentional and almost defiant vagueness, its tacit refusal to be specific to the decade of its creation. In many ways, its specific roots can be traced to Disney's *Winnie the Pooh* shorts and feature in the 1960s and 1970s. These stories traffic in nostalgia as much as *Toy Story* does, as if an adult version of Christopher is experiencing a half-remembered dream with all of his toys getting into lighthearted adventures. *Toy Story* is more conflict-driven, but equally concerned with memories of the past; this movie, which was once on the brink of being thrown into the cinematic trash heap, has become the driving force of its generation of filmmakers.

Cinematic nostalgia is easy to recognize because of our familiarity with what it depicts. The once-forgotten detritus of one generation's pop culture has become a cocoon in which the next generation gladly and firmly wraps itself. Those who flock to the *Transformers* films do so because they remember playing with Optimus Prime as children, or watching the robotic exploits in an animated series. The Marvel Cinematic Universe appeals to a broad audience, but the core fan base knows these characters from their youth. These are not new characters, but immediately familiar ones. Ironically, a majority of nostalgic revivals rooted in hand-drawn animation—from *Dumbo* to the *Peanuts* movie—are being redone with a heavy reliance on computer animation and effects, a direct but inadvertent byproduct of Pixar's success.

Pixar Animation Studios has become the high watermark of family-friendly storytelling, as well as computer animation, to the point where other studios have focused their efforts squarely on CGI.[4] John Lasseter and company did not intend, by making features at Pixar, to supplant hand-drawn animation or any other form; they merely wanted to add to the diverse ways in which animated stories can be told. In *The Pixar Story*, Ed Catmull said, "To think that 2-D was shut down and that we were used as

an excuse to shut it down was awful."[5] Computer animation is decidedly modern, where hand-drawn animation is considered quaint and old-fashioned, a relic of the past.

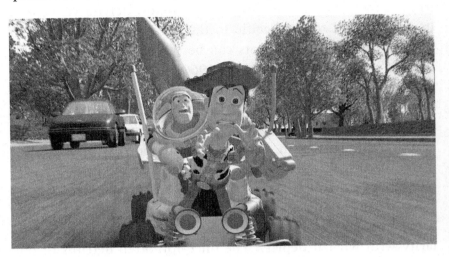

Buzz Lightyear and Sheriff Woody, riding atop Andy's RC car, lose their grip on Slinky Dog as they try to return to Andy's embrace before he moves to a new house. This moment occurs directly after one of the few era-specific pop culture references in Toy Story, *as "Hakuna Matata" plays on a car radio.*

Yet ironically, if not for a handful of unavoidably specific references and props, including a moment of corporate synergy, *Toy Story* could just as easily take place in the 1960s, when Lasseter was in the middle of his own adolescence, as it does in the 1990s. During the climactic, controlled-chaos chase sequence where our heroes, Sheriff Woody and Buzz Lightyear, try to get free of a seemingly intimidating surface street and back into the safety of a moving company's eighteen-wheeler to join the rest of their plastic friends, there's a brief gag wherein Andy Davis's baby sister, Molly, giggles and coos, seeing Woody and Buzz desperately hanging onto Slinky Dog for dear life as they ride atop a remote-controlled toy car in the rearview mirror. The punchline is what we hear on the soundtrack: the chorus to "Hakuna Matata," from *The Lion King*, playing on the car radio. All in all,

the joke takes up ten seconds of the eighty-one-minute feature, and is the most culturally specific moment that pins the film to its year of release. (Only because *The Lion King* remains a massive touchstone in Disney's animation canon does this scene not now feel dusty and dated.)

Aside from that, *Toy Story* manages to achieve a sense of universality by eschewing specificity. Andy, Molly, and their unnamed mother—we don't even learn the family's last name until the third film—do not live in a clearly defined city or state; throughout the trilogy, there are references to the "tri-county area," but nothing more. The cars, trucks, and minivans populating the locale in this action set piece and elsewhere are generic, not tied to a recognizable make or model. The world of *Toy Story* is unmistakably *ours*, with its themed restaurants and predictably lazy employees; its vast spectrum of youth, from the prickly to the precious; and its multicar pileups that devolve into wordless shouting from frazzled drivers. A throwaway gag or two aside, it could be our world circa the 1990s or '80s or even earlier. By embracing the vague, *Toy Story* enters the realm of timelessness.

The core conflict of *Toy Story* is deliberately similar to so many buddy comedies: whether two opposing figures can become friends, or at least learn not to sabotage each other whenever the opportunity presents itself. On a surface level, however, the struggle isn't about Buzz and Woody's rivalry-turned-friendship. It's about whether a little boy will choose to play with a cowboy or an astronaut, which wasn't a key debate among most children of the nineties. "Two words: *Sput-nik!*" is the acrid explanation offered to Woody in *Toy Story 2* when he wonders why his popular *Howdy Doody*–style TV show, called *Woody's Roundup*, was canceled in the mid-1950s. That sentiment applies equally to the clash here. The goodhearted sheriff battling an intergalactic party-crasher has its roots in the pop culture of John Lasseter's childhood, not that of generation X or generation Y. The same is true of the other toys in Andy's bedroom, culture clash aside: Mr. Potato Head, a Barrel of Monkeys, an Etch-a-Sketch, a nonde-

script dinosaur, and so on. For a modern kid, Andy Davis thankfully appears to be unaware of the existence of videogames, and blissfully content to play with whatever hand-me-downs he can find.

Sheriff Woody is on top of the world, or at least at the top of the food chain in Andy's bedroom, as *Toy Story* begins, yet he remains secretly fearful about the prospects of the boy's sixth birthday party. He dreads that it'll be accompanied by something, *anything*, that could upend his prior state of subtly power-driven nirvana. His barely contained neuroses aren't unfounded, as he's soon replaced as the leader of Andy's room after that party by Buzz Lightyear, a spaceman toy with bells, whistles, and all sorts of gadgets that impress the child's less easily worried, less cutting-edge playthings. This isn't to suggest that Andy's other toys don't display a range of emotions; however, their personalities, whether it's Rex's perpetually frayed nerves or Mr. Potato Head's blustery swagger, aren't informed by being atop a power structure. Much as Christopher Robin's playthings in the Hundred-Acre Wood represent different facets of a child's personality, so, too, do the toys in Andy's bedroom—all the way down to the mischievous squeaking shark in his toy chest.

Buzz is certainly flashier and cooler than Woody—a TV commercial shown at a key moment communicates both the intense, rapidly paced, and pushy tone of modern toy ads as well as the notion that a Buzz Lightyear toy is a ticket for a little boy or girl to become instantly accepted by their peer group. But Lasseter's inspiration for Buzz, even in the early phases of production and development, were space toys like Major Matt Mason, a relic of the sixties.[6] Although Andy's transition from handmade, pull-string dolls to those with computer-designed gadgets was common for anyone growing up at the end of the twentieth century, the dilemma of whether to favor one straight out of the Old West or one from the outer reaches of the galaxy has its roots in the retro-futuristic style of 1950s and '60s popular culture.

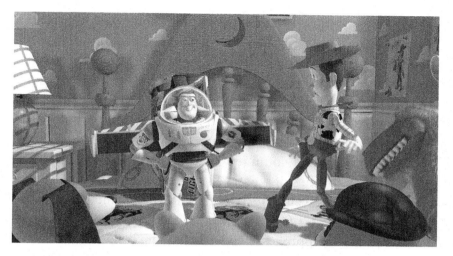

Buzz Lightyear, upon arriving as a surprise gift for Andy on his birthday, proudly displays his wings to Andy's adoring toys (as well as the skeptical and fearful Sheriff Woody).

Andy's bedroom (and thus, his childhood) is out of time. It's a holdover from the era before computers had a vice grip on children, who played instead with toys and games they could hold in their hands: those they could touch and squeeze and throw and bounce off walls. *Toy Story* opens with his latest fantasy, where the stoic sheriff in the middle of a dusty Western town faces off against a fearsome outlaw and his posse. Once the toys are shaken out of the boy's goofy reverie, we find that Woody is not quite as pure of spirit as Gary Cooper in *High Noon*. More so, what could easily be a straightforward Western pastiche becomes absurdist instantaneously via childish constructs. Andy lets his mind spin away from the basics of the genre and turns his playtime into something grander and more outlandish, much as the filmmakers themselves do with the buddy comedy subgenre.

By the end of the film, the good guy wins the day and the girl, and both members of the odd couple turn out to be the best of friends, but the ways in which these conclusions occur are wholly different from the safe choices of years past. Though he's a more complex character than Cooper's taciturn Will Kane,

Woody does wind up on his own within about a half hour of the opening scene, as the rest of his old friends forsake him for the fancy new toy who can "fly" and shoot a red blinking light from his forearm. Buzz Lightyear heralds a new beginning for Woody and the other toys, just as *Toy Story* represented a sea change in the world of feature animation, and in all of cinema, twenty years ago. Woody is the sole holdout, unwilling to accept the forces of change even as his counterparts give themselves over to the unlimited possibilities of whatever mysteries exist in the future.

But *Toy Story*, as well as its sequels, succeeds primarily because it acknowledges and firmly embraces the notion of childhood, the idea of sidestepping the future and regressing to the early days of our lives in the hopes of forever being enveloped in warm memories. In effect, it sides with Woody, who desperately tries to maintain the status quo before gradually accepting that a little change never hurt anybody. (His acceptance is a tough blow softened by the final punchline, wherein even Buzz has to deal with change, in the form of Andy getting his very own puppy for Christmas.)

The soothing comfort of nostalgia is at the core of the film's development, as is the notion of fantasy. Woody, for example, was based partly on a Casper the Friendly Ghost toy that Lasseter had loved dearly as a child, to the point where his parents only knew he was asleep because Casper stopped talking.[7] It's easy to trace Lasseter's own feverish pretend scenarios to the way this film opens: with young Andy creating an action-packed sequence from his imagination, using whatever toys he can to fill in the blanks. It's also easy to track Lasseter's desire to imbue his toy with life to his equally intense choice to direct films about inanimate objects with surprisingly three-dimensional personalities.

The other toys in Andy's bedroom, with or without an identifiable brand name, were clearly chosen by Lasseter and the rest of his creative team precisely because they would be familiar to the baby boomers who brought their kids to the theater. A Mr. Potato Head, a Barrel of Monkeys, a porcelain Little Bo Peep, a

bucket of soldiers: all of these and more were toys children knew and had related to for decades. And giving a fictional name to a hot new toy was far wiser than having Woody square off with an actual Cabbage Patch Kid. Lasseter was correct to presume that throwing in newer, specifically real toys would rob *Toy Story* of any potential enduring power, specifically because their popularity would likely wane in the decades to come.[8]

Some of Andy's toys, including Rex, Slinky Dog, and Mr. Potato Head, create a makeshift rope using the contents of a Barrel of Monkeys to try and save the missing Buzz Lightyear.

Such practicality is absent in *Cars*, a film borne as much from Lasseter's life as *Toy Story*, both as a boy and as a man. He grew up around cars, as his father worked in a Chevrolet parts dealership in Whittier, California; he's also repeated countless times that a road trip he took with his wife and children one summer across the United States in an RV, a few years after Pixar began making features, inspired the film's high concept as much as any childhood memories.[9] Lasseter and his co-director, the late Joe Ranft, took their love of real cars and transferred it into cin-

ema, in part because they saw a personality inherent in these life-less objects. The 1952 Disney short "Susie the Little Blue Coupe," whose eponymous heroine had eyes located in her windshield, served as an inspiration almost as powerful as the "Mother Road," Route 66, which Lasseter had explored on his family road trip as well on various subsequent trips with Pixar animators and historian Michael Wallis.[10]

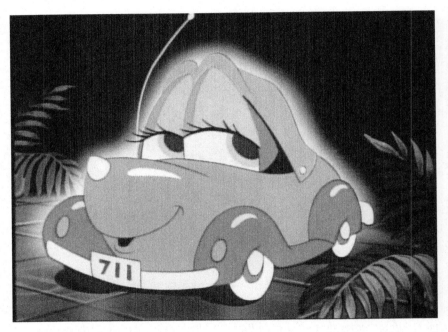

The eponymous character of the short Susie the Little Blue Coupe (1952) served as visual inspiration for John Lasseter and his animators as they developed Cars (2006).

The world of *Cars*, though, is far more specific to its 2006 release—often to its detriment. It's perhaps impossible to know for sure, but "Hakuna Matata" could have been forced onto *Toy Story*, an executive-suggested in-joke shoved in at the last second instead of being the product of genuine inspiration.[11] By the time *Cars* opened, however, Pixar could mostly do as it pleased;

they'd triumphed over their only true villain, Eisner, who left the Walt Disney Company in early 2006 after a fan-driven campaign led by Roy E. Disney turned shareholders against him.[12]

Considering Eisner's antipathy to the studio, it's hard to imagine that casting Larry the Cable Guy wasn't a wholly conscious decision on Pixar's part. Commenting on *Cars 2*, Mr. Cable Guy once said, "John Lasseter heard me on the *Blue Collar* CD and he said, 'That's the voice. That's the voice of Mater.' "[13] Thus, when Mater shouts out the infamous "Git 'er done!" catchphrase in the sudden-death race climax of *Cars*, it is not a case of corporate soullessness, so much as an instantly dated and dead-in-the-water, off-the-cuff gag created to sate the adults in the crowd; even then, only some of them might've appreciated or even understood the reference.

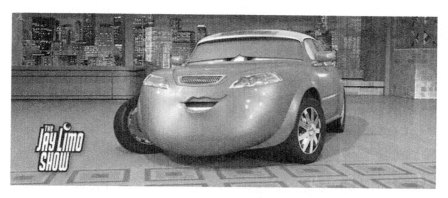

Some of the various cultural references in Cars (2006) come in the form of celebrity cameos. Late-night talk show host Jay Leno appears in the film as Jay Limo, functioning much the same as he does in live-action comedies: commenting briefly on the lead character's plight.

This is, admittedly, cherry-picking; *Toy Story*'s references to popular culture are few and far between, and some of them are noticeable only aurally.[14] *Cars* does not wait very long to introduce the idea that its anthropomorphic vehicles exist in, essentially, our world circa 2006, full of celebrities and cell phones and neon-hued accessories. After the protagonist, Lightning

McQueen, psychs himself up before the opening race, we're thrown headlong into a lengthy bit of exposition delivered by Bob Costas and former NASCAR driver Darrell Waltrip, renamed Bob Cutlass and Darrell Cartrip in a *Flintstones*-esque stab at adult-facing humor.[15]

In this respect, the first *Cars* is the exact opposite of the first *Toy Story*: to understand the majority of its humor in the opening and closing acts, let alone laugh at it, you have to be cognizant of the period's pop culture landscape. Only then will you grasp why one of the costars of *Blue Collar TV* would riff on his familiar gags as a beat-up tow truck, or appreciate references to public-radio icons like Tom and Ray Magliozzi, or chuckle at an in-joke regarding Pixar's own predilection for casting John Ratzenberger in each of its films in even the briefest of roles. For children, *Cars* is a fun way to spend two hours with vehicles that talk; for adults, *Cars* is top-heavy with pop culture references, which are absent or at least less frequent in every other film from the studio. Radiator Springs, where much of the action occurs, is meant as a place lost in time, freeze-dried for Lightning McQueen's enjoyment and spiritual revival. But *Cars* is wholly a product of its era, and is thus at odds with its own mission statement, failing to balance modern cultural references with an old-fashioned, low-key sensibility.

The *Cars* films stand apart from the rest of Pixar's output, not only because they represent a qualitative step down (even *A Bug's Life*, which is arguably a weaker effort, is more consistently enjoyable), but because they announce themselves as products of the 2000s. Though John Lasseter directed both films, the differences between *Toy Story* and *Cars* are fairly simple. *Toy Story* responds to existing nostalgia, whereas *Cars* attempts, forcefully, to create it. *Toy Story* concocted a world where human characters existed on the periphery, their absence holding as much weight as (if not more than) their presence. *Cars*, however, concocted a

world that doesn't allow for human characters, despite being one of the most photorealistic and technologically innovative films Pixar's ever made.

There were practical reasons why Andy isn't in much of *Toy Story*, becoming more deity than child; the technology to create humans with computer animation was far less aesthetically pleasing than objects of plastic origin, for one. Pixar's technology had improved enough since their 1988 short, *Tin Toy*, where the title character outruns a scary and disturbingly bumpy-faced infant, but not so much that we could even see what Andy's mom looked like above the waist.[16] Although this could have easily been an obstacle for the film, *Toy Story*'s filmmakers used this limitation to force themselves into an inventive fix.

By removing Andy from *Toy Story* as much as possible, Lasseter and the rest of his team made the film utterly familiar to its audience members, young and old. Most people could see themselves as Andy, spending his time with a Slinky Dog and a piggy bank and a Mr. Potato Head and soldiers and sharks, playing checkers and Operation and Battleship. The children watching *Toy Story* saw themselves as Andy at the same age (or maybe a couple of years older), but their parents didn't feel as if they were watching something foreign or inexplicable. They weren't confused about why a kid wouldn't want to leave the house without choosing a toy to accompany him. They were not dragged to this film, as it goes for so many family-centric pictures. Andy's childhood was *their* childhood, with a few new variations on what surrounded their young lives.

The imbalance between a love of the past and a forward-looking future is present as far back as *Toy Story*;[17] Sheriff Woody feels self-conscious and bitter at being left behind by the populace's embrace of the new. Woody was made by hand, whereas Buzz was made by computer. Though Buzz comes to accept that he was made instead of born, and that his purpose is not nearly as grandiose as he initially announces, his creation is presented as superior throughout the franchise, to Woody's cha-

grin.[18] He appears to have fewer limitations than Woody, whose bitterness feels earned almost as soon as Buzz arrives on the scene. Woody eventually lets Buzz win, dubbing him "a cool toy," much as many presume computer animation is simply cooler than hand-drawn animation, a mild win for the future over the past.

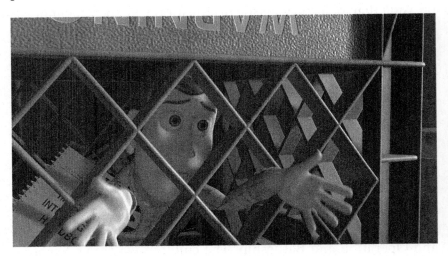

Sheriff Woody, now trapped in the bedroom of the psychotic child Sid, convinces Buzz that being a toy instead of a galactic space ranger is an extremely important job, and clarifies why Buzz's presence in Andy's bedroom inspired such envy.

Toy Story not only heralded the beginning of feature computer animation; it was a key factor in introducing the power of nostalgia to the point where it is now inescapable in modern culture. Before Pixar's first film, there were TV shows like *Happy Days* and *The Wonder Years*, idealized versions of the fifties and sixties that sugarcoated their respective periods' inherent flaws. Cinema entered an era of nostalgia tentatively in the 1990s, and seems unlikely to evolve in the near future.[19] What movie studios do nowadays with their various big-budget projects, throwing millions upon millions of dollars into CG special effects to revive transforming robots, superheroes, and more began on a much smaller level with Pixar's debut feature. Lasseter may not have

intended to create a flashpoint for the whole of mainstream cinema, but such is the power of *Toy Story*. Depicting the childhood of a little boy who plays with dolls was a journey Lasseter made for himself as much as for the millions of people around the world who self-identified with Andy.

Like Pixar as well as *Toy Story*, *Cars* is defined by a self-aware dichotomy. The battle raging in the 2006 film is between the message imparted through the story and the manner of its presentation. The valuable lesson that the brash, dismissive, self-centered race car Lightning McQueen must learn by the end of *Cars* is to reject his hard-wired beliefs. The first word he says is "speed," which he should avoid whenever possible; those around him encourage Lightning to appreciate his life at a slower, more relaxed pace. For better or worse, *Cars* follows suit, content to be Pixar's most low-key and laid-back entry.[20] In making an accidental and lengthy pit stop at Radiator Springs, a once-popular small town on Route 66 that's fallen on hard times, Lightning learns the value of taking his time. He does so by appreciating Radiator Springs' place in the America of the 1950s, before freeways allowed cars to bypass quaint little burgs in favor of reaching their destination quicker.

Radiator Springs recently became a living, breathing entity uncreatively dubbed Cars Land at the Disney California Adventure theme park in Anaheim, California. This is the logical progression for a recreation of a time when life moved slower. Cars Land is John Lasseter's Main Street, USA, the introductory section of Disneyland Park and Walt Disney World's Magic Kingdom meant to represent a turn-of-the-twentieth-century small town. Cars Land is equally a three-dimensional distillation of a retro style, even if its existence is but a half-remembered dream of a stop in the middle of a road trip long past, much like an amalgamation of the Midwestern towns Walt Disney grew up near in the early twentieth century.

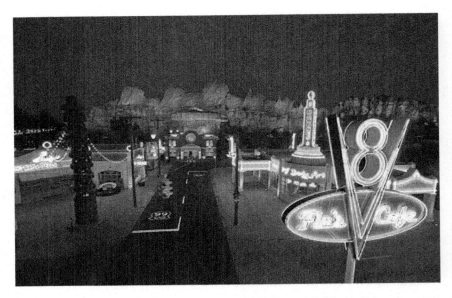

This nighttime shot depicts the Cars Land area of the Disney California Adventure theme park in Anaheim, California. The entire area is a recreation of Radiator Springs, as depicted in Cars (2006).

Cars Land is just further proof that the "world of *Cars*" now exists chiefly as a merchandising cash cow—Disney's personal version of Hot Wheels. The 2006 film spawned a rare beast indeed for Pixar: a sequel that was widely panned. Eventually, it also begat two spinoffs that were originally intended as straight-to-DVD releases but eventually wound up in theaters: *Planes* and *Planes: Fire and Rescue*. (Both of these films—the former manages to be as offensive as *Cars 2*, primarily by invoking the real events of World War II for cheap pathos—follow the basic plot structure of *Cars* to a T.) If the early legacy of Pixar Animation Studios was the out-of-nowhere success and influence of *Toy Story*, then its current legacy may be inextricably, unavoidably tied to the exploits of the denizens of Radiator Springs.

Because of Lasseter's increased involvement and presence within the Walt Disney Company, specifically the theme parks, it's easy to look at him as a twenty-first-century Walt Disney. Like Disney, Lasseter has eased into being the symbolic face

of the company to audiences worldwide, more a figurehead or human mascot than a hands-on filmmaker. Since Disney acquired Pixar in 2006, Lasseter has only directed two films: *Cars* and *Cars 2*.[21] The story of Lightning McQueen and his friends speaks to Lasseter and his experience—his own road trip mirroring Lightning's in terms of learning the value of slowing down—even if that retold experience leaves something to be desired.

Lightning comes to realize that the past is a cure-all, a soothing balm that a select few can wholly appreciate. The denizens of Radiator Springs want nothing more than for other vehicles to discover their home—in one scene, they try desperately to lure in two lost suburbanite minivans, to no avail. But to accept the town, you have to be attuned to its charms. Lightning's come-to-Jesus moment occurs roughly halfway through, as he goes on "a drive" with Sally, a shiny and sleek Porsche with the equivalent of a "tramp stamp," which she laughs off during a flirtatious moment.[22] She exhorts him to take a ride to nowhere in particular; in doing so, Lightning finally realizes that he's driving through a most beautiful and rugged landscape.

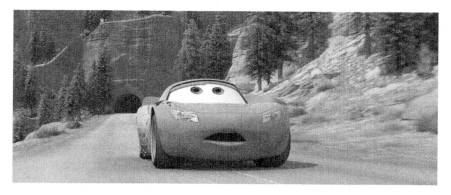

Lightning McQueen, while sidelined in Radiator Springs, is gobsmacked at the natural beauty of the world surrounding him; he functions as a surrogate audience member, impressed by Pixar's photorealistic animation.

After some playful back-and-forth racing, where Lightning ends up with debris in his grille, Sally reveals that she used to be an attorney in Los Angeles who became disillusioned with her work and "fell in love" with the natural beauty of the American Southwest.[23] She reveals that Radiator Springs' prospects have been consistently low since Interstate 40 was built mere miles away, saving drivers ten minutes. The humble little spot is now a ghost town, its glory days scored to a mournful number called "Our Town," sung plaintively by James Taylor. Despite the romantic angle being more believable than these characters falling in love with a town instead of each other, the scene is one of few in *Cars* that mostly works.

This moment of clarity only succeeds because it was devised with some of the most jaw-dropping, realistic computer animation ever presented in cinema.[24] Throughout, *Cars* avoids the infamous "uncanny valley" effect that occurs often in high-tech computer animation, wherein audiences recoil at what's on screen because of how close it comes to achieving humanlike accuracy. By depicting objects that are inanimate in our world, Pixar sidesteps the uncanny valley even when creating a pitch-perfect version of the American Southwest.

For years, Pixar's technology improved exponentially between releases; though *A Bug's Life* only features human characters as shadowy figures in a quick gag about bug zappers, the designs and backgrounds of Ant Island are lush and vibrant—a leap forward from the generic suburbia of *Toy Story*. And so it progressed until (and after) *Cars*, which accomplished the impossible: in the wide shot communicating to us what happened when the interstate freeway system was built over the previously expansive and primarily untouched Southwest desert, it looks as if someone simply filmed the real mesas and plateaus of Arizona instead of animating the scene. In this respect, *Cars* is at war with itself: its backgrounds and structures are exquisitely designed to a point

where they might legitimately fool audience members, while the characters existing within those backgrounds and structures are, displayed in close-up, deliberately cartoonish in nature.

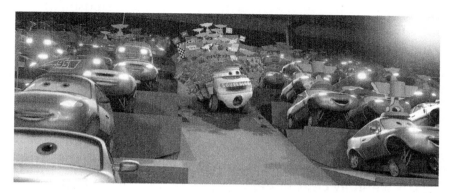

The photorealism of the backgrounds in Cars (2006) is often offset by the deliberately cartoonish design of the cars' faces and eyes, as displayed in this early crowd scene.

Visually, *Cars* represents the finest computer animation that Pixar has offered in its two decades of making feature films, if not in terms of storytelling. Though *WALL-E* and *Up*, in particular, are excellent pieces of storytelling that take leaps forward in emotional complexity and character depth, the worlds those films' characters occupy are slightly less tethered to our own, with futuristic cruise ships and talking dogs manning biplanes. They approach realism at times, but are constantly heightened. Perhaps that's why the illogic of the world of *Cars* strikes some critics as bothersome. Lasseter tacitly refuses to explain how this world came to be because it's the same one we inhabit, just with cars and no humans.

More than most Pixar films, *Cars* confronts the destructive power of modernity on the good old days. This movie that bemoans the calmer attitudes of the past couldn't exist (or inspire a real-life location sharing its name) without the fast-paced mentality of the future. Watching *Cars* is to watch the inverse of *Toy Story*: Lightning's corollary is Buzz Lightyear, a fast-paced interloper who steamrolls over the pre-established leadership in town

(this time, it's the gravelly Doc Hudson instead of Woody) and presumes that his reputation precedes him. Lightning doesn't exactly forsake his celebrity, but learns, as Buzz does, that he needn't be defined by that fame to be worthy of friendship. Buzz doesn't have to be a space ranger; he just has to be a toy. Lightning McQueen doesn't need to be the fastest race car in North America; he just has to be a car.

But what truly binds together *Toy Story* and *Cars* is that its lead characters are not only aware of the hold nostalgia can have over any of us, but that they accept it. The wistful longing for the past in both films isn't subtle, in part because John Lasseter didn't want to obscure it from the viewing audience. His message is painfully clear in *Cars*: "Weren't things better back in the old days?" He depicts it visually and verbally, with much greater impact than he ever could with *Toy Story*. But the 1995 film, so fleet and economical, is an exceptional piece of work, whereas *Cars* is hampered by its constant grounding in the twenty-first century. Lasseter's nostalgia for his childhood was a powerful tool for change, when utilized delicately. *Toy Story* transcends the current wave of nostalgic mainstream blockbusters, approaching iconography without forcing its hand. *Cars* falls right in line with those films, aiming simplistically low in its storytelling even as its aesthetic approaches a kind of perfection. No matter how crisp and colorful and slickly made *Cars* is, however, it never reaches the same level of complexity as *Toy Story*, because it focuses too hard on making its world immediately identifiable via empty, hollow markers of time. The best kind of mainstream cinematic storytelling respects and pays fealty to the power of the universal.

TOY STORY 2 AND UP

Nostalgia's presence in modern filmmaking has become unavoidable, thanks in part to all the countless reboots, remakes, and other mulligans we'll be inundated with in the next few years. Precisely because so many children of the 1970s, '80s, and '90s are willing to give pieces of culture that deign to poke and prod their memories the benefit of the doubt, it's rare that a movie studio would not just directly confront and criticize nostalgia (and do so frequently), but clarify its worst elements in two of its most thrilling, sharply written films. Via lead characters in *Toy Story 2* and *Up*, Pixar Animation Studios acknowledged the fact that a love for the past can be mentally damaging when it's the only reason someone wakes up every morning. What's more, both films criticize nostalgia via instantly memorable and utterly heartbreaking montages, offering up the best possible examples of Pixar's ability to render even the most stone-faced adult a crying child in the face of their dialogue-free work.

Toy Story 2 is not primarily a text on nostalgia, but among the new characters introduced to Woody, Buzz, and the rest of Andy's toys are a desperate, terrified, and selfish old man whose resentment is borne from a love of the past, as well as a complex woman who cannot move forward because of how her past weighs down on her. It's sometimes too easy to rely on hard statistics to criticize Pixar for not having enough intricately detailed female characters to compare to its many complex male characters. A report at *The AV Club* in 2014 noted, via a Tumblr post,

that four of Pixar's first fourteen films pass the Bechdel Test, which tests whether movies have female characters with names who talk to each other about something other than men. Only one of Pixar's films has a female protagonist, and less than 25 percent of Pixar's characters are women.[1] Despite these shortcomings, they've nevertheless crafted fascinating character backstories reliant on feminine influence, most notably in *Toy Story 2* and *Up*.[2]

Briefly, a prime example is *The Incredibles*, the Brad Bird–helmed superhero film featuring two passionate, three-dimensional female characters: Helen Parr and her daughter, Violet. More importantly, *The Incredibles* is driven by its protagonist's obsession with the past; Bob Parr, formerly Mr. Incredible, keeps newspaper articles, magazine covers, and other souvenirs of the past in a dedicated room of his house, and keeps trying to perform acts of vigilante justice so he can reclaim his faded heroism. Bob ignores his present—the potential of being a good father and husband—in favor of striving for past glory, even if it kills him.

The struggles depicted onscreen in *Toy Story 2*, and the devastating honesty of Jessie's backstory, are important to consider when framed against the publicly disseminated behind-the-scenes headaches that plagued the film. First envisioned as a direct-to-video sequel, albeit one made in-house, it was hard for those at Pixar to feel comfortable with the setup. "Even though I wrote the treatment, I remember thinking, 'I don't know if we should do this,' " Pete Docter later admitted. "Do your A-level film, then crap out the sequels direct-to-video, and basically make more money off the first one."[3] Though the stories vary—either it was a joint decision between Disney brass and Pixar's filmmakers, or it was Joe Roth and Peter Schneider viewing story reels in 1997 and realizing it was too good not to release in theaters—the result was clear: *Toy Story 2* had to be a theatrical release, and it had to open in November 1999, no matter what.

While it's impressive that, unlike the *Cars* franchise, *Toy Story* was able to steer clear of the graveyard of direct-to-video sequels, the production team was nearly unable to deliver a finished product, let alone a good one. The problem, as documented in the various media that make up the Pixar mythology, from the various "art-of" books to *The Pixar Story*, was thus: John Lasseter knew *Toy Story 2* could be improved if he and his team had more time to update the project, but Disney refused to budge from its Thanksgiving 1999 release date.[4]

The very fact that *Toy Story 2* remains vitally resonant and potent more than fifteen years after its release is compounded when you realize it was rebuilt from the ground up in just nine months. The manner in which movies are produced has changed vastly since Pixar began making feature films; many people who pay attention to such projects from the development phase through completion presume the worst when any hint of a shift in production is announced.[5]

A nine-month turnaround on any major film isn't unheard of, but it's become far less frequent in the twenty-first century. Rarer still is a film with such a quick start-to-end timeline that winds up being considered one of the great sequels—one that's so good that it might improve upon its predecessor.[6] *Toy Story 2* is, in some ways, a greater act of cinematic wizardry than *Toy Story*, made all the more successful considering its heft and universality. The ways in which the film deepens our knowledge of Woody, informing his own choices through his new friendships, feel antithetical to a rushed production schedule, and wholly natural to the series's growth. Moreover, the decision to allow Woody to share focus with new, fully lived-in characters is more mature than the production schedule would seem to allow.

Jessie the Yodeling Cowgirl (performed excellently by Joan Cusack) is arguably as thorny, neurotic, and defensive as Woody is in the original *Toy Story*. She displays a wide range of emotions from moment to moment precisely because, as it's slowly revealed, she's at the precipice of her existence. We meet her

only a few days before her fate will be determined for good; she believes she'll either be forever enshrined in glass or thrown callously into storage, never to be seen again except by an adult collector whose love of the past is driven by a love for money instead of a love for toys. Her identity is as a bauble, with or without value.

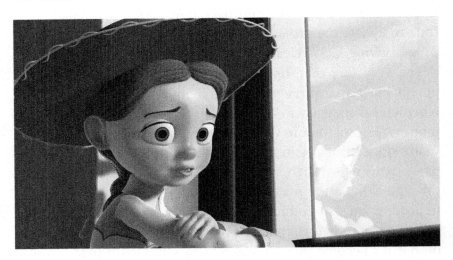

Jessie, one of Woody's Roundup gang members, reminisces about her old owner, a girl named Emily who outgrew her and left her on the side of the road, at a key emotional peak of Toy Story 2 (1999).

When Woody first encounters her in Al McWhiggin's high-rise apartment building, Jessie is portrayed as a starstruck fan, which is all the more perplexing to Andy's favorite toy because he wasn't previously aware of *his* true identity. It turns out that Woody isn't just an old-fashioned pull-string doll; like Buzz Lightyear, he existed in some form before he wound up in Andy's bedroom, as the lead of a massively popular 1950s children's TV show, *à la Howdy Doody*, and Jessie was one of his faithful sidekicks. Once Jessie realizes that Woody—Andy's Woody (and really, *our* Woody)—isn't the vision of heroism she has in her mind based on the old *Woody's Roundup* videotapes she's worn out over time, she turns bitter and acrimonious. Jessie's rapidly

shifting moods are smartly captured both in the character animation and in Cusack's exquisite voiceover work, but her unpredictable nature is given far greater depth once she tells Woody of her past and what brought her to such a low place, wanting to be kept behind glass and gawked at by tourists in a foreign country.

The "When She Loved Me" sequence in *Toy Story 2* is one of the most important in the entirety of Pixar's filmography. The studio's films, after two decades, are easily identifiable based on a series of touchstones: There are the original characters, who often display a depth of humanity in spite of most of them not being human; the quirky voice casting that's less reliant on the actors in question being big-name movie stars who can lure in audiences, and more on their appropriateness for their roles; the jaw-droppingly photorealistic animation, which improves on an annual basis; and the ability to make adults collapse in a flood of tears.

Eschewing dialogue, Jessie's memory of her time with Emily, scored to the Randy Newman song "When She Loved Me," culminates with a moment of joy as she sits next to her now-teenage owner before being donated unceremoniously to a toy drive.

Toy Story has a comparable scene at its midpoint that's meant to tug on the audience's collective heartstrings, also scored to an original Randy Newman song. However, the moment when Buzz Lightyear realizes his limitations, forced to accept that he can't really fly as he tumbles and unceremoniously hits the floor of his captor's house, doesn't have the same gut-wrenching power as the flashback montage depicting the rise and tragic fall of Jessie's life as the favored toy of a girl named Emily. As with many of Pixar's most tear-jerking moments, the scene is effortless in getting people to reach for a Kleenex; Sarah MacLachlan, who performs the number, has a lovely voice fraught with emotion and a sense of melancholic regret. Her plaintive tones coupled with the sun-dappled imagery and Jessie's face, turning so quickly from giddiness to hollow despair, make this song a standout in the studio's history.

For Pixar, emotion-driven nostalgia is most universally felt without dialogue. Jessie doesn't speak during the "When She Loved Me" sequence—nor does anyone else, though there's muffled background chatter when she sees Emily as a teenager (at least, the girl's feet shuffling back and forth), talking on the phone in her boy-crazy bedroom. The same is true of Jessie and the rest of the toys in *Toy Story 3*, remaining stoic and silent in the fiery climax; words aren't necessary. The best example is WALL-E, a robot that doesn't speak as it looks up to the stars and imagines sharing its unremarkable life with someone, or something, else. By removing the very opportunity for dialogue in the "When She Loved Me" montage (as there don't appear to be any other toys with whom to interact in Emily's room), Jessie's pain becomes shared among the audience, so pointed and direct that it also inspires guilt.

We have all been—or *are*—Emily, outgrowing our toys (or growing into new ones, as she ages into teenybopper posters and makeup, leaving behind an obsession with horses) and abandoning them when they outlive their usefulness. Watching Jessie get left behind by her owner at an outdoor Goodwill depository is

akin to a parent feeling abandoned by their own child, growing past parental needs in adolescence.[7] The scene works so well and remains so powerful more than fifteen years after the fact because we see ourselves in both characters in the montage, depending on when we revisit *Toy Story 2.*

During the "When She Loved Me" montage, Jessie watches with horror and despair as Emily's passions turn from horses and cowgirls to makeup and boys.

Jessie cannot move on from the past, at first outright refusing to; she grows nasty because those around her can't possibly measure up—hence her scornful tone when Woody talks about Andy. The more specific his relationship is to someone outside of the core *Roundup* gang, the more alone she feels. Only after she risks her life countless times does she consign herself to a fate that's better than death; only when she takes a literal leap of faith is she able to let go of the past and accept the love of another child, even while knowing that said child will outgrow her.

This lesson is one that all of the toys have to learn—and will be directly confronted with in the third film—as Stinky Pete bluntly asks Woody if he really expects Andy will take him or any of his other toys to college, or on his honeymoon.[8] An overriding message of Pixar's entire filmography is that while it's

possible to remain obsessed with the past, down that path lies doom. Woody's neuroses, which manifest so frequently in the trilogy, may be borne out to some effect,[9] but his bullheadedness is depicted as bordering on cruelty here, as when he snaps at the cute-and-cuddly horse, Bullseye.

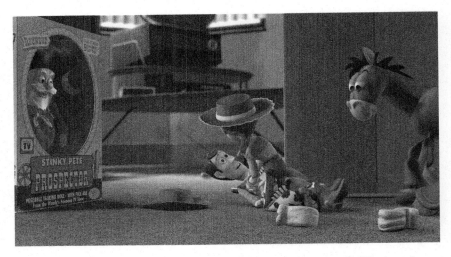

What looks like a violent gang-up to Buzz and the other toys is actually Woody and Jessie, with Stinky Pete the Prospector and Bullseye looking on, creating their own version of Woody's Roundup for pleasure.

In truth, the entire *Woody's Roundup* gang is shown to be quite stubborn in *Toy Story 2*; each is given a solid reason why, but only Stinky Pete the Prospector is unable to back away from the edge of oblivion, unwilling to accept the possibility that kids like Andy exist, let alone right around the corner. To Jessie, Pete represents the worst extreme of what happens when you're unable to truly let go of the past. Jessie is terrified of the possibility of abandonment to the very end of the film, nearly refusing Woody's help even though she's on a flight that won't bring her any happiness.[10]

Woody, when presented with the option of banal immortalization, nearly allows himself to be tempted, to be frozen in time and briefly acknowledged by strangers on a daily basis. For

an indeterminate amount of time—potentially more than two decades, based on the retro style and color of the posters in Emily's bedroom when she's grown beyond toying with a cowgirl doll—Jessie's life has been building to this moment. She, like many other Pixar protagonists, from Bob Parr to Carl Fredricksen, has spent years thinking only of her past, of the glory days. There is no present; only the blips of memory in which she got to be the star and her adventure seemed infinite.[11]

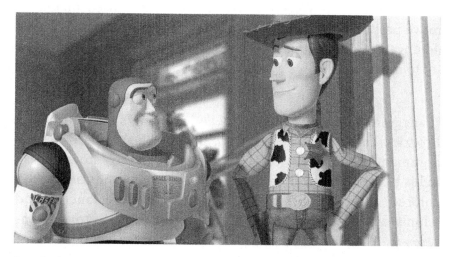

Buzz Lightyear and Sheriff Woody, at the end of their most recent adventure, take stock of what their future might hold when Andy outgrows playing with action figures.

The *Toy Story* series has a bedrock foundation of nostalgia. The first film's core struggle is between an astronaut and a cowboy, figures of pop iconography whose power was far diminished by the 1990s; the second film's core struggle is about the value (or lack thereof) of permanently staying in the past.[12] Woody, more than the other characters, has to constantly grapple with the challenge of accepting change and moving on. Only in the second film does he experience this as a spectator, even when dealing with his own issues. Jessie's internal battle—balancing her innate fear at being left behind with the hope of being loved

again—is waged as much for her own sake as it is a lesson for Woody to embrace the terrifying unknown of what will happen to *him* when Andy grows up.

While some critics have taken issue with the *Toy Story* sequels as being repetitive in theme or plot (Woody's inadvertent abandonment here at a yard sale being multiplied in the setup for the third film, for example), it's still an accurate reflection of humanity; we do not so quickly change our ways, even as change is thrown at us. For Woody to frequently find himself unable to move past being Andy's toy, and occupying only that role, is less an unrealistic trope than an honest depiction of our own inability to move on.

"I am going to Paradise Falls *if it kills me!*" shouts the infirm Carl Fredricksen in the 2009 film *Up*, during a particularly heated argument he's having with a boy who inadvertently stowed away in his house when he lifted it to the sky via thousands of brightly colored balloons. *Up* is clearly among the more fanciful and whimsical films Pixar has made in its twenty-year history of features (if not American animated films at large over the same period). But when Carl says this, in part because of Ed Asner's fierce and committed voice performance, it's obvious that he means it in the most literal sense. At that point, Carl is not so much hovering near death as he is spiritually dead already.

The Carl with whom we spend the majority of the film, who utters hardly a word or two more than his younger self did, is the shell of a happier, kindlier man who sold balloons at the local zoo while his beloved wife, Ellie, worked as a zookeeper. Ellie turns into a memory no more than ten minutes into *Up*, one that drives Carl to achieve the impossible even as it sends him to the brink of madness and despair. Leaving aside the visual similarity of men dragging large structures through a thorny and mysterious jungle, it's not shocking that co-writer and director Pete Docter consulted films like *The Mission* or Werner Herzog's *Fitz-*

carralido for inspiration.[13] Herzog's men are incurable obsessives; Carl is somewhat luckier, but just barely.

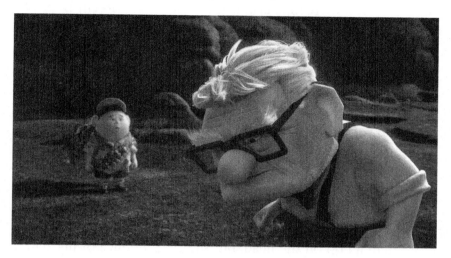

In this grim moment from Up (2009), the elderly hero, Carl Fredricksen, has a furious emotional breakdown when his old house is partially burned down and his journey begins to seem more suicidal than whimsical.

The stakes are made clear as soon as we meet the square-jawed, Spencer Tracy–esque Carl, after Ellie has passed away: he whacks a construction worker on the head with his four-legged walker (replete with tennis balls on the bottoms of each leg) and draws blood with the wound. It's not unheard of for an animated film—especially a big-budget picture distributed by a monolith like Disney—to show blood, but it's extremely uncommon.[14] Even the most iconic and stereotypically harrowing moment in all of Disney animation—when Bambi's mother is shot by a hunter—occurs entirely off-screen. We may expect violence in animation, short or feature, but the consequences of violent acts are rarely, if ever, shown in an even slightly realistic fashion. We are more accustomed to watching characters like Donald Duck or Wile E. Coyote take all kinds of beatings, only for them to spring back to life in the next scene, completely unharmed.

When villains in Disney films die, they do so out of eyeshot as frequently as possible. The only time Pixar has depicted a villain's demise onscreen is at the end of its most violent film, *The Incredibles*, when the bitter Syndrome is sucked up by a jet engine, which subsequently explodes.[15] But even *Up* falls back on one of the most familiar Disney death tropes, when Charles Muntz falls off his zeppelin, thousands of feet to the ground, much as Gaston falls from a castle spire in *Beauty and the Beast* or the poacher McLeach tumbles from a waterfall in *The Rescuers Down Under*. As soon as he falls through the clouds below the zeppelin, it's as if Muntz never existed at all.

But it's Carl's attack on a well-meaning person, an innocent bystander who accidentally knocks a mailbox off its axis, that grounds *Up*. Carl only draws a slight amount of blood, nothing more than a bop on the head, but the consequence of his action is so startling that it balances out the fantastical elements to follow. Even as he embarks on an adventure with flying houses, never-before-seen birds, and talking dogs, Carl's tragic loss and his moment of primal fury hover above him throughout. Few moments in Pixar films remain more shocking than this bit of violence, coupled with the subsequent gasps and pointing from passersby and the reaction shot of a sweaty and desperate Carl.

The event is all the more impressive because of how successful Docter, co-writer Bob Peterson, and the rest of the filmmaking team are at imbuing inanimate objects like a mailbox with a backstory. Carl's attack, and subsequent court case, occur within the first fifteen minutes, by which time we've already met and lost Ellie, who leaves behind scrapbooks, pictures, and, here, a handprint on an old mailbox. To anyone else, Carl's attack is irrational—a sign of senility and possibly dementia. To us, after a few brief moments, it's a serious and painful violation of a man's life.

A nameless construction worker inadvertently knocks Carl's mailbox off its beam, causing the old man to strike him and draw blood—a rare instance in modern animation.

Carl's response to potentially being forced out of his home and into an assisted-living facility is, of course, inherently ridiculous. Anyone able to lift up a house with balloons (and *only* balloons) defies logic, especially when the *anyone* in question is an elderly man who requires automated help traversing a flight of stairs. What constantly tethers this outlandish setup to the ground is Carl's struggle with the past. The montage in the first act, scored to Michael Giacchino's sweet and intentionally repetitive track "Married Life," has been praised by countless critics as one of the very best, if not the best, sequences in Pixar's history. Lisa Schwarzbaum noted that it's "as deeply textured as any great novel";[16] Sheila O'Malley accurately pointed out that the montage "is a masterpiece of how *little* you have to do to hook your audience in for the long haul";[17] and Roger Ebert said the sequence "deals with the life experience in a way that is almost never found in family animation."[18] The placement of this sequence in the first act is necessary, because Carl no longer has

the luxury of his comfortable life with Ellie. All he has are fractions of memories, mental montages he cannot stop playing in his mind.

It's these same memories that function as the majority of Ellie's adventure-themed scrapbook, spending time with her husband in the real world instead of the fantasy one they created as children, though Carl is too stubborn to look past the "Stuff I'm Going to Do" title page until he's at his lowest point in Paradise Falls. Like Jessie, Carl's present is tied to an absent woman who once loved him beyond compare; like Jessie, he wants to run as far away as possible from his problems, so that he can be enshrined, in a way. He presumes that his trip to the undiscovered land of Paradise Falls will let him live out a shared dream, and place him alongside his idol in the history books.[19] Carl, at least, is given some level of guidance by Ellie (who he chooses to believe represents the spirit of the house), whereas Jessie is wholly abandoned by Emily.

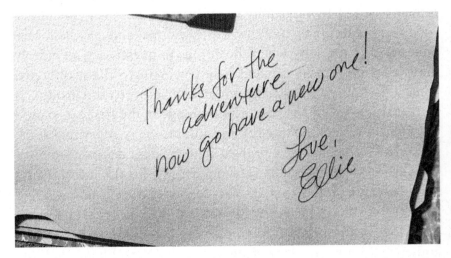

Carl finally looks at the second half of his late wife's adventure-themed scrapbook and realizes she left him an extremely important message as a guide for the future.

In both cases, survival is assured because the character hopelessly besotted with the past is given a helping hand. This happens literally in both *Toy Story 2* and *Up*: The former, when Woody extends his hand to encourage Jessie to live out the never-seen conclusion to the final episode of *Woody's Roundup* as they hold on for dear life on a commercial airliner. The latter happens on a constant basis, as the young, energetic Russell is on a literal, Boy-Scout-in-everything-but-name quest to help a senior citizen to do . . . well, *anything*. Neither film suggests that nostalgia, on its own, is bad; however, the necessity for any of us to move on from the past, only keeping it in mind somewhat as we live in the present, is the key to their futures.

In the film's opening moments, a young Carl nervously approaches a run-down house where a young Ellie—his future love—plays as an adventurer, inspired by their mutual idol (and eventual antagonist), Charles Muntz.

The comparisons between these films extend beyond Jessie and Carl; much as Stinky Pete the Prospector represents the worst of nostalgia, so too does Charles Muntz to Carl. It's fitting that the nefarious, Christopher Plummer–voiced adventurer is named after Charles Mintz, the real-life figure who finagled away control of Walt Disney's first animated star, Oswald the

Lucky Rabbit.[20] If the characterizations are accurate, Muntz's single-minded and cruel attempt to stake some kind of personal control in anything new and different in his surroundings isn't terribly far off from how the real Mintz acted.

Muntz initially brings Ellie and Carl together; his "Adventure is out there!" credo is what lures Carl to the dilapidated old house where Ellie imagines herself as an explorer à la the dashing, Lindberghian figure. His quixotic journey to capture a never-before-discovered avian creature, and thus reaffirm his derring-do to the now-doubting public, sends him into a psychotic spiral. When Carl and Russell first encounter the elderly man—both Carl and Muntz are well into their senior years, but Muntz has to be a couple decades older—Carl reverts back to his childhood stance of hero worship, giggling like a schoolboy at the very thought of entering Muntz's zeppelin, housed in a cave near the falls. Here, too, Carl is guilty of embracing nostalgia too tightly. Even before Muntz menacingly reveals that other people have met a nasty end in Paradise Falls,[21] his presence there is clearly unnerving. And yet, in spite of how Carl is brought to the antagonist's lair, he drops all pretense when he gets to meet his hero.

As with most cases in fiction, from *The Wizard of Oz* to *Twenty Thousand Leagues Under the Sea* to even *The Incredibles*, when our hero gets to meet his personal idol, he walks away with his ideals destroyed.[22] It's not five minutes before Muntz threatens to kill Carl and Russell, even if the story of how they arrived on his zeppelin is the oddest one he's heard yet; a few scenes later, he tries to burn "Ellie" down and nearly succeeds. In moments like this one, *Up* tackles the past in a literal way; one man's obsession with his past drives him to destroy another man's as tangibly as possible.

But Muntz can't have it so easy in Docter and Peterson's vision; Carl is able to live out another fantasy he and Ellie shared as youngsters, co-opting Muntz's past heroics into some of his own by manning Muntz's zeppelin in the climax. Muntz, however, is as unable to control someone else's destiny as he is his

own. Thus, there's something truly gratifying and gleefully cathartic about one of *Up*'s final images: that of Carl and Russell sitting at the front of the zeppelin, the former strapping on the goggles he once wore as a kid sitting in a 1930s movie theater and finally moving on from his elongated childhood, accompanied by Michael Giacchino's swooning score. It's almost as powerful as Carl thumbing through Ellie's scrapbook and realizing she kept it going throughout their relationship, or Carl literally letting go of the past by allowing the house to float away through the clouds. He still indulges in his childhood fantasy—what else could this flight back to suburbia be called?—but he's grown up enough to move on, figuratively and literally.

Neither *Toy Story 2* nor *Up* is entirely able or willing to leave the past behind. Jessie winds up with a new owner and group of toys, but is still haunted by memories of her time with Emily.[23] Carl finally achieves a most impossible goal, one he couldn't reach with his wife when she was alive: he gets to be a parent, albeit a surrogate, to Russell, whose biological father clearly has no time for him or his Wilderness Explorer desires.[24]

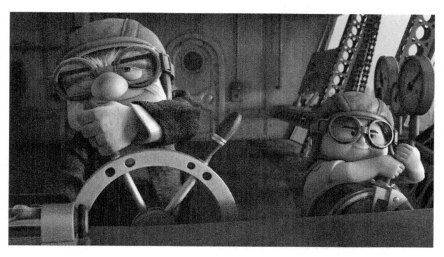

After defeating Charles Muntz, Carl Fredricksen and his young charge, Russell, gear up and ride Muntz's zeppelin back home; Carl has finally gotten to live out two of his dreams: having a true adventure and being a father figure.

Ellie couldn't be a mother to anyone aside from, perhaps, the animals with whom she worked at the zoo; when we see her sitting defiantly, eyes closed, in front of her house after finding out that she can't have kids, it is evidence of her pushing past this trauma, choosing not to dwell on the negative. Carl, at least, gets to see this reality achieved, pinning the so-called "Ellie badge" onto Russell's sash at the end of the film. But he accomplishes this goal, unspoken throughout the picture, while still indulging his inner child. The final poignant shot may put a pin in the idea of Ellie's dream of traveling to Paradise Falls, yet seeing the house rest atop the Venezuelan cliffs essentially confirms that Carl's quest had a purpose beyond moving on from his wife. And Jessie, by allowing herself to have a second chance, achieves her own goal, one too terrifying to say aloud for fear of ruining it: being loved again and accepting that said love may be finite. Nostalgia may have driven Carl and Jessie to the brink; only through self-awareness and honesty are they able to survive anew.

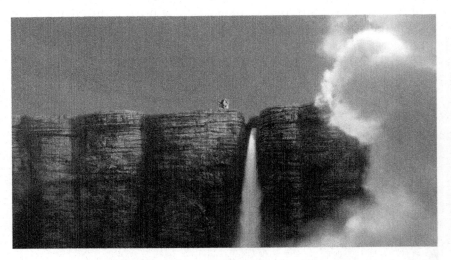

In the final shot of Up (2009), we see that Ellie's dream of having her house live atop Paradise Falls has come true.

TOY STORY 3 AND *MONSTERS UNIVERSITY*

As much as it can be said that the films of Pixar Animation Studios focus on characters who struggle with the hold they allow nostalgia to have on their actions and motivations, it's equally necessary to acknowledge the message these characters learn: it's vital to move beyond the past. In short, onward and (hopefully) upward. Carl Fredricksen must accept that the time he spent with his true love, Ellie, is gone, and he must also embrace the future and live in it completely; Bob Parr must accept that his superheroic feats of derring-do as a young man cannot be repeated with the same level of freedom now that he's middle-aged, and that the next chapter of his life is paternalistic and familial, but an adventure nonetheless; Marlin the clownfish must accept that his son is no longer a baby in need of constant coddling, and allow himself to become a less protective father, and so on. Much as these character arcs are inspired by the journeys Pixar's filmmakers have gone through,[1] two of Pixar's more recent films are equally reflective of its less experienced filmmakers' efforts to move beyond the studio's past and grow into their own styles in the shadow of an immense legacy.

That these films are *Toy Story 3* and *Monsters University* makes that attempt to grow even more difficult to achieve. The former is Pixar's most successful film, a potent and emotionally wrought continuation of the company's most viable franchise, one that grossed over a billion dollars worldwide.[2] The latter was well reviewed and financially successful, but the conventional wis-

dom surrounding the film was that it was an inevitable step down from its predecessor. *Monsters University* is one of only two Pixar films to not get a Best Animated Feature Oscar nomination since the creation of the category.[3] However, while people may have presumed (and still do) that the sequel will be the death of Pixar, *Toy Story 3* and *Monsters University* offer solid proof that Pixar can create a kind of meta-commentary on its own history as well as audience perception of their characters, crafting nostalgia not from its filmmakers' childhoods so much as the now-grown audience's memories of Pixar's earliest films.

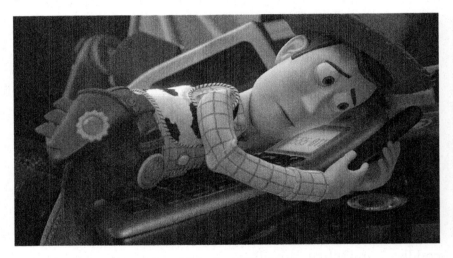

In a sign of how far the toys have fallen, Sheriff Woody tries to get Andy to play with them by making a prank call in the first act of Toy Story 3 (2010).

Both of these films feature protagonists who are initially unwilling to accept that their dreams, those goals which push them to keep on living each day, are completely unobtainable. Their refusal to accept reality unwittingly turns into an embrace of obsession. Woody the pull-string doll is, as ever, driven to ensure that his identity is inextricably linked to Andy, the owner he often treats as a deity; he's unable to accept the possibility that he will or should ever be anything aside from what's branded on his boot. Although he's known for years that he can't stop the boy

from aging, Woody's desperation mounts all the way to making crank calls just to get his attention. He's smart enough to realize that when the toys are placed in the attic, they'll likely never get played with again, even if Andy has children of his own decades later. But he's not yet self-aware enough to admit his time with Andy is at an end.

Then there's Mike Wazowski, who, in a pleasant surprise, takes the spotlight in the 2013 prequel to *Monsters, Inc.*, functioning as an avatar of his creators. When Mike first arrives at the eponymous college, he's established as a superfan. He's idolized myriad "Scarers," whether they're famous for being terrifying or not, since he was a child. He looks at these creatures, either from the trading cards he wields or when sneaking into the Monsters, Inc. factory, and assumes that he'll wind up a Scarer himself, ignoring what literally every other character who offers an opinion on his talents tells him: "You're not scary," as intoned by the imperious Dean Hardscrabble. Woody and Mike are setting themselves up for failure as soon as their respective films begin.[4]

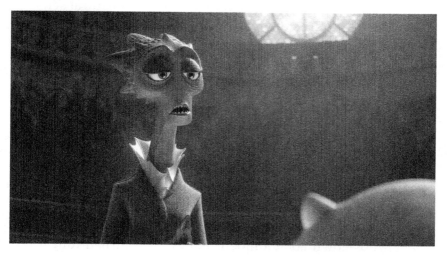

In a key moment for a younger Mike Wazowski in Monsters University (2013), he's told by the fearsome dean of the eponymous educational institution why he can never be a Scarer: "You're not scary."

Lee Unkrich, who was the sole director of *Toy Story 3*, was no stranger to Pixar, having worked as an editor and co-director at the studio since the first *Toy Story*. However, with the 2010 film being credited to writer Michael Arndt (who won an Oscar for his *Little Miss Sunshine* script, but had not worked officially on a Pixar project before), and people like Lasseter, Stanton, and Pete Docter taking a backseat approach, this was clearly a Lee Unkrich film, featuring his take on the characters.[5]

As in prior films, Woody remains steadfast and unwavering in his conviction that his home is with Andy, physically or spiritually; whether he exists as a prop in the young man's dorm room or as a forgotten relic in the attic doesn't matter, as long as it's in Andy's vortex of awareness. In the first two films, Woody's beliefs are affirmed; he may need to unloose his neuroses slightly, but he's not wrong to find solace as Andy's toy. Here, however, Woody's finally proven wrong, even though he's correct to presume that Sunnyside Daycare is currently not an ideal replacement.[6] The other toys are all too happy to move to Sunnyside, precisely because it allows them to push Andy's natural sense of abandonment to the side in favor of anyone playing with them.[7] It's Woody who has to literally and figuratively move on from one owner to another. In the end, granted, he doesn't so much escape nostalgia as allow himself a downgrade from the leading player in one child's imagination to solid support in someone else's more hyperactive and freewheeling brain.[8]

But nothing is ever that simple in the *Toy Story* films, which delight in piling on complications for our heroes. Neither Woody nor the rest of the toys who survived Andy's high school years can just move on to the young girl Bonnie or to a gentler daycare setting easily.[9] First, the toys must face off against a miniature tyrant whose own abandonment issues have turned him nasty, culminating in a literal trial by fire that's one of Pixar's most emotionally powerful moments as well as one of the most memorable and subtle payoffs to a gag in modern cinema.

Family animation rarely dives into such potentially morbid territory; Unkrich and Arndt's choice to push Andy's toys so close to the brink of literal death recalls the climactic inferno of *Bambi*. Pixar's hallmark for wringing tears out of its audience as if they're trying to flood each theater hits its zenith here. As much as the final scene traffics in audience nostalgia, the realization the toys have that there is no escape and the resultant collective decision to face death honorably is extraordinarily moving—as well as a mature way to cap off a series of films predominantly aimed at families with young children. Just as we watch Andy literally hand off parts of his childhood to someone at the end, we're being forced to witness the possible death of those same parts, and in the worst possible way. The final scene of *Toy Story 3* is almost a dream, but this sequence is a nightmare. Our heroes survive, allowed to resume their place as tokens in some child's mind.

In one of the great cinematic payoffs, the toys are saved from a fiery death by the trio of little green alien figurines, who have finally gotten a chance to control the Claw.

By their very nature, toys are frozen in a state of arrested development, a fact that's hinted at by the film's villain, Lots-o'- Huggin' Bear (Ned Beatty at his folksiest, until he's at his cru-

elest, as fierce as the soulless suit he played in *Network*). Most of Andy's toys are tempted by the utopia he describes: always being played with and wanted by a child (or multiple children), and never being abandoned. Based on Lotso's description, Sunnyside is a haven of perpetual motion, making it so the toys won't collect dust for more than a night or two. Woody is wary (after an initial and overly friendly tour), but only because he craves singular attention, presuming it can only come from Andy and nowhere else.

The end of this journey for Andy's toys, as they get one final playtime with Andy in the middle of an idyllic front yard, approaches an animated parallel to Richard Linklater's *Boyhood*: we have, in effect, dropped in on the childhood of Andy Davis, seen through a unique prism, over a period of fifteen years. The relationship between films is accidental—it's doubtful that anyone at Pixar thought, in 1995, that a third *Toy Story* would exist in this form in the twenty-first century, let alone be nominated for Best Picture—yet unavoidable. One of the many achievements of the *Toy Story* series to date is that shared by *Boyhood*, and is arguably a more impressive accomplishment. The existence of a series documenting the modern American childhood in this extended fashion is so rare, and so carefully constructed.[10]

But just as *Boyhood* shouldn't be judged solely on the nature of its production (and is superior to being judged on such details), the same is true of *Toy Story 3*. Initial claims that Unkrich's film fell back on the familiar, or was simply too repetitive relative to its predecessors, ignore the complexity on display in characters like Lotso and Woody, the former of whom may seem familiar on the surface but is a darker extension of our hero instead of a rehash of a past villain. Cultural scholar Myles McNutt acknowledges the emotional power of the hellish climax, but suggests that "this film is *designed* to reach this conclusion."[11] He continues, "Lotso is awfully similar to Stinky Pete, and it's not like the series hasn't done action-adventure storylines in the past two films." No doubt, the *Toy Story* films are action-packed (and the open-

ing sequence tips its hat to the previously unseen fantasies Andy concocts in explosive fashion), but almost every Pixar film has an action sequence or two; for this film to continue in that vein is natural rather than repetitive. And though Lotso, like Stinky Pete, has his own selfish aims in mind at all times, the teddy bear is meant to represent the darkest possible side of Woody in ways that Stinky Pete the Prospector never did.

Lotso, seen here as he realizes he's been replaced by his owner, Daisy, and turns truly evil, is the main antagonist of Toy Story 3 (2010). This shot is a visual homage to director Lee Unkrich's favorite filmmaker, Stanley Kubrick, and the so-called "Kubrick stare" motif.

Like Woody, Lotso knew the power of a child's love, as he was once the darling of a little girl named Daisy. Woody's greatest nightmare, depicted in full in *Toy Story 2*, was total abandonment by Andy, a terror that Lotso lived out for real.[12] Lotso and two other toys, Big Baby and Chuckles the Clown, are inadvertently left behind by Daisy after a trip, forced to return home on their own. When they finally get back home, they discover that Daisy's parents simply replaced the old pink teddy bear that smelled liked strawberries with a new one.[13] And so Lotso arrives at

Sunnyside Daycare and becomes an unrepentant tyrant, forcing every other toy through the same humiliation and abuse he suffered so that they can unknowingly relate to his pain.

Lotso and Stinky Pete may similarly represent the grimmer sides of Woody's neuroses, but they represent different concerns: Stinky Pete is what Woody may become if he submits to never being held by a child again, where Lotso is what Woody may become if he submits to being held by too many children. The difference is in how humans interact with these toys: one receives no physical connection, and the other receives brief and meaningless moments of connection. Both Lotso and Stinky Pete are villains, and both are selfish; however, they are not bitter for the same reason. To suggest that they're repetitive is to suggest that any antagonists in a follow-up to a piece of culture are repetitive, simply for being antagonists.

Lotso lives with a tortured nostalgia, concurrently wistful for the times when he lived an idyllic existence with Daisy and loathing himself and everyone around him for the conclusion of that existence. In effect, he exists as a warning to Woody, just as Jessie existed as a warning to Woody in *Toy Story 2*. "This could be you," they might as well be intoning; *he* could be donated to Goodwill or carelessly left behind after a long day away from home. Woody remains stubborn almost to the very end, avoiding the obvious realization in front of him for most of this film's second act: to leave Andy behind would not be such a tragedy if he could find another child to love him as deeply. Woody's not tied to one true love, as it were; the charming and hyperactive Bonnie is a fine replacement for the little boy who became a typical teenager.

Transposing this narrative arc onto the people who made this film—Unkrich and Arndt, specifically—it's not hard to see them as having decided to follow in Woody's footsteps. Instead of stubbornly believing that the only way they can succeed at Pixar is by following the path that was created before them, they allowed themselves to accept that they must create their own path for-

ward.[14] That notion becomes even more challenging when, as in both cases in this chapter, a filmmaker must work with a preexisting world and characters, both of which are intimately familiar to audiences worldwide. The nostalgia that fueled *Toy Story*, the memories John Lasseter and other animators may have had of their childhood toys, becomes subsumed in the (currently) final entry in the franchise by the nostalgia audiences and the filmmakers have for *Toy Story* itself.

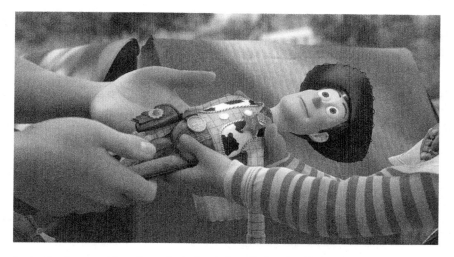

In the final scene of the trilogy, Andy Davis literally hands off Sheriff Woody to the young and ebullient Bonnie so that he may be played with in another generation.

Where *Toy Story 3* steps right, and where most revivals of past pop culture staples fail, is in its clear and unsubtle acknowledgment that moving on is not only valuable, but necessary.[15] Woody doesn't verbalize his decision to have Andy pass off all of the toys to Bonnie; it's made subtly in the final twenty minutes, from the point at which he stands defiant and together with his friends against a belching, explosive, all-consuming fire to skipping college with his old owner. The subtlety of the decision—visualized in part when Andy nearly, instinctually, yanks Woody back away from Bonnie as if she's a thief trying to steal the pull-string doll—is what makes the choice so powerful in the

end. Andy couldn't bring Woody to college with him, because the toys that remained in his bedroom were all facets of his childhood personality. To bring one portion with him to adulthood would be to live a fractured life. Just as it's possible to tell unique and special stories even with familiar characters, it's possible to be fulfilled by a different source of adolescent love. Pixar's filmmakers and Woody only reach this state of acceptance by acknowledging and moving beyond their past.

The prequel is an inherently lifeless and problematic staple of modern mainstream cinema, because its core hook almost always fails to impress: how did the worlds and characters we love come to be? Sure, it's great to watch Luke Skywalker, Han Solo, and Princess Leia get into various scrapes, but what about Luke and Leia's father? What was Darth Vader like before he donned the black mask, back when he was known as Anakin? Was he always a villain? If he wasn't, what caused him to become one? The *Star Wars* prequels are perhaps an easy target, but the cardboard characterizations, dull action, and colorless performances that lie within essentially inspired many of the people who lined up to buy tickets for *The Phantom Menace* in 1999 to become hardline skeptics as soon as they left the theater. Arguably, even if those prequels weren't quite so poorly executed on the whole, the revelation of how Anakin came to require a new look couldn't possibly have delivered the kind of punch fans were hoping for.

So many prequels fall into the same trap that George Lucas and the *Star Wars* prequels did, birthed from a high-concept idea that rarely meets expectations or deserves to be turned into a feature. The hook for *Monsters University* seemed weaker than most—what if Mike Wazowski and James P. Sullivan met in college and hated each other's guts instead of being fast friends? There's little, if any, tension in the premise, simply because anyone who saw *Monsters, Inc.* knows Mike and Sulley *are* best friends in the present, if not the past. How they become friends

seemed less exciting than watching them embark on an adventure when they're closer. The surprise of *Monsters University* is that the real story *isn't* about Mike and Sulley's eventual friendship or how it comes to be, but about the protagonists facing limitations and expectations that they cannot control, insurmountable obstacles imposed upon them by society. Mike struggles to accept that he cannot live his dream of being a truly memorable and talented Scarer; Sulley struggles to rebel against the highborn reputation of his family. Through them, we can see the obstacles faced by the people who made the film, from director Dan Scanlon (in his feature debut) to other animators working on the project.

Mike Wazowski, as a child, idolizes the Scarers at Monsters, Inc., to the point where he follows one of his heroes into a human child's bedroom to see him at work. His stealth impresses the Scarer, even though it terrifies his teacher.

Mike, we discover, was a superfan first, treating the Scarers at Monsters, Inc. as idols, much as kids treat superstars like Michael Jordan or LeBron James. He collects trading cards that list these monsters' statistics like they're free-throw percentages. While these creatures are heroes to Mike, he never doubts that he will join their ranks, being as much of a hero to a visiting child when

he's an adult as the friendly "Frightening" Frank McCay is to him in the prologue. McCay inadvertently sets Mike on his path after being impressed at his stealth in sneaking into a child's bedroom unbidden. This walking eyeball, once he attends the eponymous educational institution, continues to be unwavering in his belief that he's destined for greatness, although everyone else doubts him, either initially or—in the case of his freshman roommate, the nerdy Randall P. Boggs—eventually. *Everyone* doubts Mike, and has reason to. Even the audience is skeptical: we all know Mike Wazowski isn't scary because we know the character better than he does. The only time in the series that Mike gets the spotlight on the other side of a door is in the closing moments of *Monsters, Inc.*, collecting children's laughter, not screams, to help fuel Monstropolis. So how can he be headed towards the iconography he so desires?

Mike *is* destined in *Monsters University*, of course—destined for failure. His determination is admirable, but misplaced, as he discovers in the third act when he goes into the human world to prove his talent. Instead of finding himself in the bedroom of a single child, he's inadvertently entered a cabin in a sleepaway summer camp, crowded by multiple young girls, all of whom look at him as a curiosity, a life-sized plaything who's as far from terrifying as possible. ("You look funny," one of them says cheerfully.) To be confronted so directly with the inability to live out your dream is a fairly mature concern to appear in a family film, especially one thought to exist simply to make money. But the scene in which Sulley finds Mike sitting at the edge of a lake near the camp, the moon shining bleakly on the two as they commiserate over their general failings in life, is surprisingly moving and honest—more so than the more direct emotional pleas in *Monsters, Inc.* Just as the film upends expectations, so too does this emotional climax (the true culmination, not the end of the Scare Games minutes before), taking place in a stereotypical horror-movie setting despite positing the physical monsters as being more humane than their presumed prey.

Mike and Sulley grow closer as friends after Mike's failed attempt to prove his worth as a Scarer in the real world, and Sulley acknowledges his fears of not living up to his family name.

Both Mike and Sulley are victims of the past, directly or indirectly. Sulley, it's revealed early on, is a legacy student at MU; his father, who we never meet, is one of the greats of the scaring business, so it's only natural that his big, blue, furry son would follow in his footsteps. "You'll never know what it's like to fail, because you were born a Sullivan," Mike spits at Sulley before the latter reveals it's that mindset that terrifies him on a daily basis. Sulley's suffocated by nostalgia outside his own choosing, the wistful assumption that he can relive his family's past by his very existence; Mike would rather flee back to the dreams he had as a child, the visions he had for his own future being brighter, easier, and more successful than it appears it will become. Looking at the people who made *Monsters University*, it's not difficult to see them as being unfairly weighted with such expectations, or walking through their job with that perception.

By 2013, Pixar was no longer an upstart in the world of animation; it was, and remains, the industry's standard-bearer. Though their competition is frequent and fierce, specifically the pop culture–driven films of DreamWorks Animation, Pixar is as pow-

erful and influential now as Walt Disney Animation Studios was in its first few decades of existence. As *Forbes* columnist Scott Mendelson once wrote, "In the eyes of the critical and pundit community, Pixar makes animated films while DreamWorks makes cartoons."[16]

With great influence, then, comes great expectations, and since the worldwide success of *Toy Story 3*, those expectations have become too great to bear. *Toy Story 3* arrived after the one-two-three punch, in three consecutive summers, of what are arguably Pixar's best original films: *Ratatouille, WALL-E,* and *Up.* All of these films took storytelling chances that are mostly unheard of in mainstream filmmaking in the twenty-first century, let alone animation, from a story with a seemingly unappealing rodent protagonist to a film with a nearly forty-minute section featuring zero dialogue to a meditation on grief. The financial and critical successes of these films culminated, thanks to some updated rules, in a Best Picture nomination at the Oscars for *Up. Toy Story 3*, despite not being original, threw adult audiences for a loop with its intense and matter-of-fact climax, where the characters seemed to be headed for whatever Toy Heaven might look like; it, too, was a huge financial success and it, too, received a Best Picture Oscar nomination.

There was, in a sense, after *Toy Story 3*, an inevitable question to be asked: "Can Pixar possibly top itself? *Should* we expect them to?" Perhaps more pointedly: was *Toy Story 3* the end of an era? Once Pixar announced that two of its next films would be sequels or prequels (*Cars 2* and *Monsters University*), the fear was that the studio was giving in to the prospect of so much cash it would make Scrooge McDuck jealous. While there was a largely positive fan base surrounding *Monsters, Inc.*, few people over the age of ten demanded a *Cars* sequel, let alone one focusing on Larry the Cable Guy's Mater. The presumption, especially since these films were developed fully *after* Disney and Pixar merged in 2006, was simple: Pixar was coasting on its fame and success, leaving behind the clever inspiration that defined its early

work. In a piece at *IFC*, Matt Singer put it best: "When Pixar makes a movie for everyone, they're geniuses. When they make a movie aimed at children, when they narrow their focus and appeal exactly how film writers often prescribe, they're lambasted for it."[17]

It is this inevitable comedown, and the related (if mild) backlash to Pixar's future—announcing sequels like *Finding Dory* and *Toy Story 4* has inspired a modicum of dread in some fans, and resignation in others—that fuels *Monsters University*. When *Finding Dory*'s production was made official, the negative reaction was so strong that Singer, now writing for *Indiewire*, had to ask: "Why can't Pixar make sequels?"[18] His more specific question, posed near the end of the article, gets at the crux of the issue. "If we all assume any original Pixar property will be a masterpiece, why do we instantly assume that any sequel *from the exact same folks* will be a disaster?" A potentially cynical (but no less accurate) answer came a day after Singer's piece, as Calum Marsh wrote at *Film.com* that "the Pixar narrative proved two Hollywood truisms simultaneously: success never lasts, and you're only as good as your last hit."[19] He posits that "our frustration at the thought of a sequel—it's not an original idea and it must therefore be lesser, the thinking goes—speaks to our deeper frustration at the thought that every film, and especially every studio film, embodies a dual impulse to create and earn."

Scanlon and the other screenwriters seem to be self-consciously aware of what *Monsters University* represents to the doubters, letting the points made by Singer and Marsh hover over their heads. In some respects, the writers were given an impossible task, one that could never fully be achieved creatively. They may have channeled their own fears into the core group of lovable losers Mike and Sulley team up with, the Oozma Kappa fraternity, better known as OK. It's fitting that the original OK pledges are accepted by Dean Hardscrabble and the other Scare Games teams, as well as being invited into the Scaring program,

whereas Mike and Sulley, with all their expectations weighing them down to the point of cheating or committing crimes, get kicked out.[20]

Mike and Sulley, to have a chance at remaining in the Scaring program, throw in their lot with the lovable but hopeless members of the Oozma Kappa fraternity, or "OK."

Toy Story 3 may have been met, when it was first teased, with skepticism, but audiences had *Toy Story 2* to offer hope. Pixar *had* made a great sequel before, and they didn't make any others in the intervening decade. But by the summer of 2013, that wasn't the case; Pixar made a less-than-desired (and less-than-enjoyable) sequel to *Cars* a year after *Toy Story 3*, and were bringing Mike and Sulley back, and only them. Ed Catmull, who serves as the president of both Pixar Animation Studios and Walt Disney Animation Studios, told *Buzzfeed* in 2013, "We're going to have an original film every year, then every other year have a sequel to something. That's the rough idea."[21] However, that still means the studio will be less reliant on original concepts and characters moving forward than in its first fourteen years. Moreover, less than a year later, the problem of balancing original stories and sequels was crystallized in another interview with Catmull in *The Telegraph*. Writer Chris Bell notes that Pixar has "been

accused of an over-reliance on sequels—a fact compounded when, halfway through this interview, Disney announce[d that] Pixar will soon start work on *Cars 3* and *The Incredibles 2*."[22]

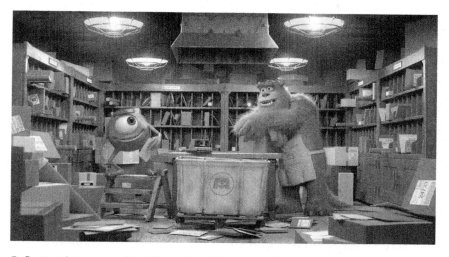

Reflecting the journey of the filmmakers, Mike and Sulley are only able to achieve their dream of working on the Scare Floor at Monsters, Inc. by starting at the bottom, as lowly mailroom employees.

Both *Toy Story 2* and *Toy Story 3* are exemplary sequels (as well as legitimately brilliant films) because they justify their existence beyond the financial needs of their distributor, a bar that too few follow-ups fail to clear. *Monsters University* is not quite as successful,[23] but its meditation on failure is an incisive meta-commentary on the film's inevitable inability to impress the first film's aging audience. The dream for so many young men and women growing up in 1995, in the age of computers becoming easier to access, may have been to join the world of animation. The reality isn't that they *can't* get into a place like Pixar; it's that these dreamers can't just *become* stars.[24] They have to work at it, and that means they have to stumble first. Their dreams, much as it applies to the people behind *Monsters University*, were not destroyed, but deferred. We know Mike and Sulley become

something akin to superstars, but they pay their dues first. They have to earn their status, instead of simply and arrogantly assuming that they'll get it by showing up.

The presumption most people held regarding *Monsters University* before it opened was that the film and its makers would operate in this safe zone: did a new entry in a franchise from Pixar need to be memorable, or did it just need to not be as bad as *Cars 2* was (or was perceived to be)? That 2011 release, directed by Lasseter himself, has no significant ties to nostalgia—even though it was clearly inspired by the spy thrillers of the 1960s and 1970s—but its impact on Pixar's recent past, present, and future is inescapable even in relation to other projects.

The specter of *Cars 2* loomed large when *Monsters University* was released, even though Pixar's batting average with sequels to that point was still .666.[25] It's not uncommon for a studio to make sequels anymore; it's the exact opposite. Pixar remains an exception to the rule, even among its competition at DreamWorks, having made four sequels in two decades.[26] But as more sequels flood the marketplace, many of which aren't in high demand, the concern is clear: our nostalgia is being snuffed out by these continuations, not stoked. A *Toy Story* sequel was risky, but it paid off; a third *Toy Story* film seemed to test fate, but managed to evoke feelings of real pain and passion, much more than any other third film in a franchise. In reality, Pixar risks far less now than it did in the 1990s. *Monsters University* or an upcoming film like *Finding Dory* is the opposite of a risk; even *Cars 2*, which wound up (based on the number of tickets sold) as Pixar's lowest-grossing film to date, was a success.[27] These sequels are an easier sell to audiences, because people don't need to be sold on a concept or new characters; they just need to be reminded of what they liked when they were younger.

But the more we're reminded of what we liked as children or young adults, the more we may prefer to simply watch what we enjoyed then. *Monsters University* is, creatively, the riskiest of Pixar's franchise entries, because it tells a story in the context

of its characters' pasts rather than their futures. It's riskier than even *Cars 2*, because of the emotional pull many audience members felt toward Sulley and Mike—riskier still because Boo isn't mentioned or referenced.[28] But by grounding its story in the past, *Monsters University* acknowledges the pitfalls of relying too much on nostalgia. Pixar has spent almost its entire filmography documenting the effects and power of nostalgia, so it makes perfect sense for the studio to clarify in such unsubtle terms its disastrous undertones.

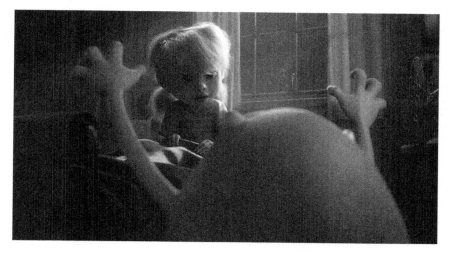

This moment, where Mike tries and fails to scare the children at a sleepaway camp, visually explains why our hero isn't scary. Even with the element of surprise, an adolescent looms over him.

Toy Story 3 and *Monsters University* should have been as catastrophic qualitatively as that overreliance on nostalgia. Revisiting the past by dragging out old favorites in an ostensibly new story that really just repeats the same notes is an easy way to court danger and mistrust among audiences, especially for a studio known for its uncondescending, intelligent, and witty storytelling. That both films arrived as fully formed, clever, and honest pieces of animation is a minor miracle. That they exist as bromides against the very nature of how they were brought to life may be slightly

hypocritical, but no less bracing and smart. With films like these, Pixar is acknowledging how difficult it is to run away from our collective pasts, but its self-awareness is what makes their work as undestructive as possible.

DISNEY ANIMATION IN THE 2010S

"Disney Animation is closing the book on fairy tales," trumpeted the headline in the *Los Angeles Times* merely three days before the release of *Tangled* in 2010.[1] In the article, Pixar Animation Studios and Walt Disney Animation Studios President Ed Catmull said: "We don't have any other musicals or fairy tales lined up." The piece further notes that adaptations of "The Snow Queen" and "Jack and the Beanstalk" had been halted mid-development, and that the less-than-incredible performance of *The Princess and the Frog* proved they aimed for "too narrow an audience: little girls."[2]

To suggest that this article, and the comments made by Catmull and others within, are hilariously alien and inaccurate may yet be an understatement. As of this writing, Disney wound up making another fairy tale, an adaptation of Hans Christian Andersen's "The Snow Queen." *Frozen* (as it was eventually called) is the studio's highest-grossing animated film—and, in fact, the highest-grossing animated film ever made. *Frozen*, a musical *and* a fairy tale, grossed over a billion dollars worldwide; is arguably the biggest cultural phenomenon from Disney's animation department since *The Lion King*; and focused on not one, but two, princesses. The two films that followed *Tangled*—*Winnie the Pooh* and *Wreck-It Ralph* (referred to as *Reboot Ralph* in the *LA Times* article)—were critical successes, granted, and not focused on female characters. But the reason why any of these films succeeded—financially, *Winnie the Pooh* wasn't much of a hit, making

only $45 million worldwide—is that, true to their word, Disney aimed less at little girls or boys, but at a far more powerful group with a much easier weapon, their parents, by focusing on the nostalgia they held for their own childhoods, much as Pixar did with the *Toy Story* trilogy. It's no coincidence that all of these films were released a few years after John Lasseter became Chief Creative Officer of the Walt Disney Animation Studios. The nostalgia that led him to a position of power hovers over this quartet of projects, but its usage and manipulation are less successful and more cynically employed throughout.

The framing device in Tangled (2010) turns its male lead, the self-aware love interest Flynn Rider, into as much of a main character as Rapunzel, if not more so.

In an alternate universe, *Tangled* would have been closer to *Shrek* in tone and style, and it wouldn't have been called *Tangled*. Longtime Disney animator Glen Keane pushed *Rapunzel* (originally called *Rapunzel Unbraided*) through development as its director, but had to step back when he suffered a heart attack in 2008.[3] And when *The Princess and the Frog* underperformed at the box office during the 2009 holiday season, the studio figured out the real problem: "Boys didn't want to see a movie with 'princess'

in the title," per Claudia Eller of the *Los Angeles Times*.[4] So, nine months before the release of a film that spent more than a decade in development and reportedly cost $260 million to create in full, *Rapunzel* became *Tangled*, de-emphasizing the girl with an excess of hair so boys wouldn't be scared away.[5]

Looking back, especially in light of the worldwide success of *Frozen*, *Tangled* merely feels like a warm-up. There are plenty of similarities between the 2010 film and Disney Renaissance pictures—Broadway-style musical numbers, a female lead who's not meant to be as passive as classical Disney princesses were, etc.—as well as earlier efforts like *Snow White and the Seven Dwarfs* and *Cinderella*. Also, though she's superficially beautiful, Rapunzel isn't too far off from the Disney-fied version of Quasimodo in *The Hunchback of Notre Dame*, with her jailer Mother Gothel a more passive-aggressive (and less sexually blasphemous) version of Judge Frollo. But the relationship that the goofy and self-consciously awkward Rapunzel has with the controlling and magic-reliant Mother Gothel, wherein the former is constantly hidden away from the real world lest its denizens ruin her perfect isolation, is not so dissimilar from the tie between Anna and Elsa.

Of course, *Tangled* exists squarely because of the other Disney princess films. Pixar's nostalgia for its filmmakers' childhood toys is comparable to Disney Animation's nostalgia, in these new films, for its own "toys," for lack of a better word. Mother Gothel is equally indebted in her creation to *Snow White*'s Queen and *Cinderella*'s Lady Tremaine, just as Rapunzel feels like a direct descendant of those films' protagonists. Rebecca-Anne C. Do Rozario writes in *Women's Studies in Communication*:

> It is in the Disney features where . . . the greatest tension is created between women. The jealous queens and evil fairies . . . repress and victimize the princess through her childhood, attempting to keep her passive and obedient. While there is a general tendency to read the princess's passivity in patriarchal terms, it is apparent that her passivity has more to do with the ambitions of the *femme fatale* . . .

The *femme fatale* attempts to keep the princess under her power, and failing that, to render her unconscious, thereby unable to validate the majesty of king or prince.[6]

This description, written a few years before *Tangled* was released, fits the film unnervingly well. Mother Gothel is only afforded *femme fatale* status because of the magic in Rapunzel's physical being; when we see her at the end, after Rapunzel's hair is shorn, she transforms into a haggard crone before dying. *Tangled*, much like *Frozen*, attempts to counteract patriarchal criticisms; in these films, the princesses' parents are either almost entirely absent or dead. The core relationships—antagonistic or otherwise—are strictly feminine, a direct throwback to *Snow White* and *Cinderella*; but there is, in *Tangled*, one major exception.

Mother Gothel, shown here in the opening moments gaining youth again thanks to the magic that ends up inside Rapunzel's hair, is a modern take on the femme fatale villainess so familiar in Disney princess films.

Flynn Rider, as voiced by the self-aware and modern-sounding Zachary Levi, can be seen as a step forward from, and an equally direct response to, most of Disney's past princes in the fairy-tale genre. He's far more multidimensional than the unnamed prince in *Snow White* or even Prince Eric from *The Little Mermaid*,

though arguably he's just as adventuresome. However, by allowing Flynn to share focus with Rapunzel, the filmmakers effectively rob her of any serious agency.[7] Flynn opens and closes the film with brief and jocular narration, so it's just as much a film about *his* journey from roguish scoundrel to a slightly-less-roguish suitor as it is about Rapunzel discovering her true identity.[8] Everything surrounding *Tangled* was explicitly designed to make clear that Rapunzel was not the heroine of her own story.

The overly enthusiastic Rapunzel wields a frying pan, her only true weapon, upon meeting Flynn Rider for the first time.

The teaser for *Tangled* attempted as painfully as possible to emphasize that, to put it in marketing speak, this wasn't your grandmother's Rapunzel. The use of the Pink song "Trouble" to accompanying images of Flynn being thrown about painfully by a mystery person shrouded in the dark, identified only by the impossibly long locks of hair on the floor near him, was meant to communicate that this was no damsel in distress, but a strong woman in control of her situation. This choice, too, is a direct response not only to decades of female protagonists, but to criticism surrounding them that suggests (not inaccurately) their passivity as characters. Some of the critiques acknowledge that

Disney's devotion to nostalgia is what allows its princess features to operate on a flexible timeline; Do Rozario writes, "Disney's creation of a sense of timelessness has in itself led to a form of perpetual reading and analysis, whereby a feature is in a constant state of being read and criticized, often alongside both earlier and later features."[9]

Yet the reality is that Rapunzel remains roughly as un-self-reliant and unable to accomplish basic tasks in this take on the fairy tale as in previous adaptations. While the playful and witty song "Mother Knows Best" makes it clear that, in spite of her nefarious machinations, Mother Gothel isn't automatically wrong to suggest that Rapunzel is clueless about the outside world, the rest of the film has less fun with the teenage girl's innocent lack of self-awareness. It's a cute inversion, for example, that a bar of ruffians turns kind upon realizing how naïve she is. The movie's inconsistency of cynicism and innocence, though, is reflected by the tonally jarring scene (and subsequent chase). And whatever hidden or healing powers Rapunzel has, representing her only agency, are almost entirely removed in the climax by Flynn (now revealed as a nom de plume for the more schlemiel-like name Eugene Fitzherbert), when he cuts off the majority of her hair as an act of defiance towards Gothel.

It's clear from the outset that Gothel's hold over Rapunzel is legitimately toxic. Her shameless cajoling and smarmy warnings are, in their own special way, more terrible and noxious than anything Lady Tremaine or the Queen ever did to Cinderella or Snow White. Rapunzel, by the close, must prove her own self-worth and get away from this harridan. Rapunzel's decision to place Eugene's life above her own, offering herself as a captive for life so that she can save him, is admirable; the resulting action Eugene takes to free her of her surrogate's control may be heroic, but it also reinforces that Rapunzel is a spectator in her own life.[10]

In choosing to adapt the *Rapunzel* fairy tale and doing so in the twenty-first century, Walt Disney Animation Studios essentially boxed itself into a corner. There is perhaps no clearer literalization of the damsel-in-distress trope than the story of the young woman trapped in a tower by a selfish witch, only to be saved by a handsome and courageous young man. Retelling the story with a consciously modernized bent makes sense; however, as winning as aspects of *Tangled* are, and as conscious as the filmmakers appear to be about how such a film could be attacked, the film winds up paying only lip service to modern notions of femininity and gender roles. This is a film intensely nostalgic for the past, yet one trying desperately to seem too cool to care—a trait it shares with another long-in-development project that embodied a more literal definition of "cool."

Winnie the Pooh was the worst financial performer of Disney's recent animated output, but was a low risk from the beginning, costing only $30 million.[11] Christopher Robin and his plush friends from the Hundred-Acre Wood have been staples of the Disney canon for roughly half a century, though they seem as old as Mickey Mouse and Donald Duck, with their low-stakes adventures representing the easiest and calmest entree for toddlers into the world of Disney's style of animation. From *The Many Adventures of Winnie the Pooh*[12] to the 1980s series *Welcome to Pooh Corner* to direct-to-DVD follow-ups, the Hundred-Acre Wood is an easy cash cow for Disney, as well as a breeding ground of pleasant nostalgia.

So revisiting Pooh, Piglet, Tigger, Eeyore, and the rest of Christopher's toys was logical, even if the 2011 film doesn't quite fit in with the rest of Walt Disney Animation Studios' recent output. The charms of *Winnie the Pooh* fall in line with what made the shorts from the 1960s and 1970s so winning and instantly memorable, further defining the new film's outlier status. While the film is a musical (with songs by Robert Lopez and Kristin

Anderson-Lopez, who would go on to win an Oscar for their work on *Frozen*), its length and depth are deliberately at odds with modern animation. A sixty-three-minute film—Disney's shortest non-package feature—with no discernible antagonist has little precedent in their canon.[13]

In Winnie the Pooh (2011), very little has changed for Christopher Robin and the toys of the Hundred-Acre Wood. They remain the calmest and safest group of characters for young children to be introduced to in animation.

The marketing for *Winnie the Pooh* was expressly targeted at adults who might have infants or toddlers, or at least people old enough to remember when heffalumps and woozles were in vogue. The first trailer was scored to the Keane song "Somewhere Only We Know," a band whose work is not automatically a signal to rouse interest in children under a certain age. Instead, this was a clarion call to those erstwhile Christopher Robins who had ostensibly left behind childish things in favor of jobs and families. The trailer is perhaps more melodramatic than necessary (and much more so than the film itself), but it signaled that parents should feel comfortable in bringing their kids to the theater as well as in potentially enjoying *Winnie the Pooh* more than their charges.[14]

The world of the Hundred-Acre Wood has always been nakedly nostalgic, beginning with the original A. A. Milne stories. The notion of a little boy playing with his toys may seem specific and recognizable only to those youngsters reading or watching the stories unfold, but for any adults in the audience, those stories are their own.[15] Just like the older shorts, the 2011 *Winnie the Pooh* is a time machine, transporting anyone who grew up with the books or the original animated works back to a time when the world was safer and simpler. Whereas many Disney films are typified by their antagonists, the Ursulas and Scars and Maleficents, the *Winnie the Pooh* stories thrive on featuring no serious threat to the status quo. The closest approximation in the new movie is an idea: that Christopher Robin is off to school and will be back soon, which becomes the Backson, a monstrous malapropism that Pooh and his friends presume has nefarious designs on them and their friend.[16]

In one of the film's musical numbers, Owl describes the fearsome monster known as the Backson, having misread Christopher Robin's note that he will be "back soon."

Though the film is decidedly American (notwithstanding the vocal performances from Craig Ferguson and John Cleese) in scope, *Winnie the Pooh* embodies the spirit best captured in the

final chapter of *The House at Pooh Corner*: "But wherever they go, and whatever happens to them on the way, in that enchanted place on the top of the Forest, a little boy and his Bear will always be playing."[17] In some ways, it's fitting that the 2011 film puts Christopher Robin on the sidelines for so long. Just as the toys in Andy's bedroom dutifully wait for him throughout the *Toy Story* franchise even though the unstoppable tide of aging sweeps him away to parts unknown, the toys in the Hundred-Acre Wood wait for their master to return so they may have pure fun once more.

The Christopher Robins of the 1970s and '80s may have grown past being able to have fun with their own silly old bears, but instead of moving on entirely, they just keep their old toys in an office, in the proverbial man cave, or somewhere else. The Hundred-Acre Wood, a more directly juvenile version of a man cave, is both a haven and, in a sense, a purgatory.[18] The 2011 film, like its predecessors, is less concerned with a serious plot—anyone over the age of five, if not a little younger, knows that Christopher meant "back soon"—than it is with, as Liam Heneghan notes in the magazine *Aeon*, "the tales of Pooh and his friends [as] a celebration of *endemophilia*, a deep at-homeness in place and time."[19]

In this sense, *Winnie the Pooh* is emphatically old-fashioned. There are more modern touches in this entry of the lighthearted franchise, such as a self-aware nod to *Mary Poppins*, but its length and ambition are oddly and admirably slight. Directors Stephen J. Anderson and Don Hall avoid any meta-commentary within the film; instead of essentially apologizing for making the movie they're tasked with, they let the film unfold sincerely and conscientiously. By paying direct homage to the original shorts, and sidestepping any possibility of turning Winnie the Pooh and his friends more era-specific, Anderson and Hall made *Winnie the Pooh* a fine conclusion to the current period of hand-drawn animation at Walt Disney Animation Studios. Like the original

shorts, this film is unselfconscious and delightfully winsome, a paean to nostalgia that simply revives the cycle for a new generation of children.

Of the quartet of Walt Disney Animation Studios features mentioned in this chapter, *Wreck-It Ralph* is most heavily indebted to *Toy Story*, and is perhaps most obviously targeting the parents in the audience instead of the children accompanying them. The setups of the two films are similar—inanimate objects humans imbue with life prove to be lively and animate when those humans are out of eyeshot. Also, the opening act of *Ralph* is littered with videogame character cameos, much as the *Toy Story* films (primarily the first two) sport cameos from mainstay toys like an Etch-a-Sketch, a Barrel of Monkeys, and Barbie dolls.

In an early example of the film's pop culture references, the eponymous character of Wreck-It Ralph (2012) walks by a billboard featuring real-life videogame character Sonic the Hedgehog.

It's not difficult to connect the development of *Wreck-It Ralph*, which went through many variations over years, to John Lasseter's ascendancy of power over the last decade. In 2005, Pixar was in the middle of fierce and potentially unsuccessful negotiations with the Walt Disney Company; due in part to Michael Eisner's stonewalling, the possibility that Pixar would be a free

agent continued to rear its head. Today, Lasseter is the chief creative officer of Pixar, Walt Disney Animation Studios, and DisneyToon Studios. He doesn't make day-to-day decisions for Disney's animated films, although all of those profiled in this chapter were completed under his watch. Thus, it's easy to wonder if the *Toy Story* connection in the finished film, for example, was less subtle and more directed.

The references come early and often in *Wreck-It Ralph*: early on, the burly bad guy Ralph walks by an electronic, exposition-spouting billboard of Sonic the Hedgehog. He also spends time in a videogame villain support group with Bowser from *Super Mario Bros.*, and says a greeting to Q*bert, among others. The film also makes reference to *Street Fighter*, *Paper Boy*, *Tomb Raider*, and more; it's scenes like the one where Ralph's in-game adversary, Fix-It Felix, all but interrogates Q*bert for information that speak to nostalgia. Kids may laugh at the little creature making inexplicably goofy sounds, but few (if any) would know what Q*bert is, or was. Their parents—as long as they're the right age—*might* snicker with recognition.

The laugh of familiarity is what distinguishes *Wreck-It Ralph*, which relied too heavily (especially in its promotional campaign) on real-world videogame references, from *Toy Story*. The humor in the film is constantly surface-level: we laugh at Ralph and other baddies commiserating over the frustration of being portrayed as villains even if they're inherently good or want to be seen as such, mostly because imagining Dr. Robotnik as needing psychiatric help to survive another day in his game is a funny enough image to get by.[20] Audience recognition does go a certain way in the *Toy Story* films—the introduction of Tour Guide Barbie in the second film is coupled with her officious tone echoing safety precautions heard at the Disney theme parks. However, seeing familiar characters from Nintendo and Sega games of old in *Wreck-It Ralph* is meant to help older audience members ignore the more generic story arc.[21]

Even the various videogame worlds Ralph occupies—from his home in the *Fix-It Felix Jr.* game, reminiscent of *Ms. Pac-Man* and *Donkey Kong*, to the *Call of Duty*–esque *Hero's Duty*, to *Sugar Rush*, a mix of *Mario Kart* and *Candy Crush*—are familiar in a way that recalls specificity. Placing an old-school character in newer, faster, more intense gaming settings is a fun gag, but one that's never explored too deeply, in favor of more jokes based on recognition alone, from references to *Tapper* to *Street Fighter* and even *Donkey Kong* itself. The recognition extends beyond Ralph's world, as well; the choice to centralize the human action—though the extent to which they hold dominion over the videogame characters is merely hinted at—in a literal arcade seems particularly and intentionally inaccurate to a film released in 2012. Even the apparatus Mr. Litvak wears, including a coin dispenser on his belt, suggests a movie frozen in time.[22]

It's a fitting theme, considering the film's frequent refrain: "You're not going Turbo, are you?" This odd phrase, always nervously asked of Ralph, is explained over time: in the early days of the arcade, there was an enormously popular racing game whose lead character, Turbo, became bitter once children moved on from his game to interact with newer technology elsewhere in Litvak's. To take charge of his destiny, Turbo essentially breaks into another game, which makes the children and Litvak presume it's malfunctioning and needs to be shut down. This effectively kills the characters in Turbo's game, as well as in the one he broke into. In a third-act twist, however, Turbo is revealed to be the Ed Wynn–esque leader of *Sugar Rush*, King Candy. He's even managed to cause a form of amnesia to fall over the game's natural inhabitants to the point where they don't realize the supposedly, delightfully obnoxious Vanellope isn't a glitch of the game, but its legitimate ruler.[23] To "go Turbo," in this film's words, is to fight a preordained role—to go against the nostalgia videogame players have for the pre-established good guys and bad guys of each universe.

Mr. Litvak, the proprietor of the arcade where the games depicted in the film are located, offers a refund to a girl who notices that Ralph is missing from Fix-It Felix Jr. via an old-school coin dispenser.

Even before Turbo reveals himself to be alive,[24] his story is meant as a sobering wake-up to Ralph, and an equally sobering reminder of the limits of nostalgia. The nature of videogames is informed by the obsolescence of old technology; when something newer and flashier comes along, it automatically becomes better than the game everyone played last month or last year. Turbo (unlike Ralph) has no issue with his role in a videogame—he simply wants to perpetually be the hero, no matter what. Arguably, what Ralph wants is worse: he doesn't, at first, want to leave *Fix-It Felix Jr.* so much as shake up the structure of the game, as rigidly designed as its other characters, who can't even walk fluidly. Turbo, unlike Ralph, is driven by his past as a daring hero; Ralph is less concerned with kids ignoring him than he is with everyone doing the same thing in spite of his very clear importance to the overall game.

The nostalgia of *Wreck-It Ralph* constantly wages battle with its story of personal introspection and attempted change, set at the periphery but designed to attract an equal amount of attention. The love of old videogame characters, and the marketing designed to target those audience members who would instantly become more interested in an animated family film, is wholly separate from Ralph and Vanellope's push-pull friendship, the

core of the project. Vanellope, indeed, is less concerned with her past primarily because she literally isn't allowed to access her memories. These characters exist as unaware pieces of the past, props in our collective memories that are given life primarily by our investment in their existence. In the end, *Wreck-It Ralph* is more concerned with the class system of videogame universes; it utilizes the nostalgia created by those universes for easy jokes and nothing more, unwilling to engage on a deeper level. Nostalgia is a crutch to this film, as it is to all of Disney's recent output, leaned upon without any deeper thought applied to its usage.

There's not a clear reason why *Frozen* became such a phenomenon. The way Disney initially marketed the film, leaning hard on Olaf the talking snowman instead of the songs or the sisterly bond, suggests that they were caught equally off guard.[25] Like *Tangled*, it's a loose adaptation of a female-centric fairy tale that was renamed to de-emphasize femininity and lure in a male audience. Like *Tangled*, it's full of songs that owe a clear debt to Broadway not only in terms of who wrote them, but also the modernized slang littering the lyrics.[26] As with *Tangled*, there's a curse at the center of the story and a fractious relationship between two women, the older of whom hides the younger one from the vagaries of the real world for as long as possible, intentionally or not. And like *Tangled*, *Frozen* is heavily indebted to the princess films of the past, trying to achieve a level of winking self-awareness about the genre's tropes while embracing them wholeheartedly and diving straight into an infinite pool of nostalgia.

"You mean to tell me you got engaged to someone you just *met?*" is the in-film critique of the classical Disney princess movie, posed as an incredulous question by Kristoff, the friendly iceman who falls in love with the person he's mocking over a few days instead of one night. *Frozen* is the latest in a slew of self-reflexive films and TV shows in the twenty-first century which

skewer old-fashioned storytelling clichés, only to run back to them when necessary.[27] If there's a problem with *Frozen*'s relationship with nostalgia, it's that it feels superfluous, a grafted-on section of a too-thin story, a sop to fans of the old way who are still wary of Disney's new direction. The kind-of, sort-of love triangle between Anna, her presumed beau, Prince Hans of the Southern Isles, and Kristoff is an extraneous subplot attached to an arguably more powerful and affecting tale of two sisters struggling to reach common ground after suffering through familial tragedy.[28]

However, because the original concept—one where, as detailed by Disney blogger Jim Hill, Elsa's embrace of her magical powers is more antagonistic[29]—was discarded over decades of production and development, the film demands a clear-cut bad guy and an equally clear-cut good guy, in the most literal sense. While it's true that *Frozen* plays fair with its sole twist,[30] the abrupt revelation is unnecessary, just like Kristoff's valiant effort to save Anna from the clutches of the ice curse she's suffering from. The relationship that matters in *Frozen* is between Anna and Elsa, which is ironically not deepened as much as it could be—as grown-ups, they spend maybe fifteen minutes of screen time together, in part because Anna teams up with Kristoff while Elsa stays in her self-created ice castle alone. For a movie built on a feminine foundation, *Frozen* backs off on exploring its sibling relationship whenever possible.

It's especially fascinating to consider where *Frozen* stumbles in its treatment of female familial relationships when comparing it to Pixar's first female-led film, 2012's *Brave*. Like *Frozen*, *Brave* is a modern take on old-fashioned fairy tales; like Anna and Elsa, Merida doesn't end up with a man by the closing credits. But *Brave* is, in spite of its well-documented production upheavals, fully committed to depicting a mother-daughter relationship without any male intrusion.[31] *Brave* is a messy film by Pixar's standards—it's the rare case where the behind-the-scenes shake-

ups seem evident in the up-and-down tone—but as Pixar's sole entry in the Disney Princess canon, its femininity is more confident and honest than that of *Frozen*.

As Anna tries to find her sister, Elsa, she enlists the help of iceman Kristoff, who expresses shock and dismay at the knowledge that this stranger is about to marry a man she just met.

Frozen is more concerned with the nebulous concept of romantic, not sisterly, love. Because Anna and Kristoff set off on a quest to stop Elsa, it means Kristoff gets to tell her about his knowledge of love, informed by "the love experts," revealed to be his surrogate family of rock-shaped trolls, who instantly presume these two are due to get married. The subsequent scene, centered on the film's least memorable song, "Fixer Upper," deflates any notion of this movie standing apart from *The Little Mermaid* or even *Beauty and the Beast*, the latter of which does feature the title characters learning to know each other before falling in love.[32] We may be encouraged to laugh at the trolls' antics,[33] but the way Anna smiles and laughs as she sees how Kristoff is dressed by his troll family, and the way he realizes his own feelings as the trolls continue to sing, aren't as easily dismissed. In the span of a single song, love becomes the only logical end for this duo.

To suggest that you can't logically fall in love with someone in a few hours because you don't know his or her personal flaws makes perfect sense. Mindless love at first sight is a frequent trope that rears its head from *Snow White and the Seven Dwarfs* all the way up to *The Little Mermaid*. *Frozen* comes close to directly opposing these examples; the film doesn't end with Anna and Kristoff being married, and Elsa is never depicted as having sexual interest in men, nor is she pushed to marry someone to share her kingdom. But Anna, scolded by her sister as well as a total stranger who happens to be handsome and in her age range, is not as self-reliant as she purports to be. She's the latest in a long line of modern romantic-comedy heroines, the klutz; she's a spiritual sister to Rapunzel. One of the first times we see the adult Anna (after she completes the mournful second half of "Do You Want to Build a Snowman?"), she's rudely woken up on the day of her sister's coronation. Her hair is cartoonishly akimbo and stuck-up, and she's snoring and drooling to boot. And when she first meets Prince Hans, it's because his horse knocks her into a boat; she then stumbles over her words: "This is awkward. Not *you're* awkward, but just because we're—I'm awkward. You're gorgeous. Wait, what?"

Anna, upon meeting her future fiancé, Prince Hans of the Southern Isles, quickly puts her foot in her mouth as they try to get their bearing in a boat.

Anna is, in this respect, roughly as incapable a heroine as Snow White or Cinderella or even Ariel; the difference is her twenty-first-century sense of self-awareness. She's smart enough to know that she needs Kristoff's help, but she's otherwise as unable to achieve most basic goals without someone's aid. Anna is closer to a post-feminist Disney princess, but the feminism on which she was created is shaky at best. She falls in line with the analysis by Cassandra Stover of the University of Southern California: "Just because a princess is no longer 'wishing for the one she loves to find her,' as Snow White does, she is not necessarily now wishing for anything grander than finding him herself."[34] At face value, *Frozen* is a glib rejoinder, as Elsa and Kristoff both scoff at the notion that anyone could fall in love as quickly as Anna. But Kristoff's love grows roughly as fast.[35] When Anna realizes this mountain man harbors romantic feelings for her, her spirit appears to lift her off the ground even as she's suffering from the ice curse.

Here, and elsewhere, *Frozen* echoes its predecessors. Hans is a modernized Gaston, an impossibly good-looking guy who attempts to wield power by vicious force; Elsa and Anna are reflective of Ursula and Ariel, with the former's magical power wielding dominion over the latter; Kristoff is partly akin to Aladdin, a poor but enthusiastic young man whose sidekick is a silent animal who understands English, and whose indomitable spirit is enough to win the heart of a princess; the Duke of Weselton is a more avaricious combination of the King and his advisor in *Cinderella*, both in design and character development.[36] The film is tethered inextricably to past stories. This tie becomes an albatross, because as much as *Frozen* wants to be different from other fairy-tale movies, it only pretends to break free from them by the finale. The victory, apparently, is that Anna and Kristoff aren't betrothed in the final moments; that may be true, but their romance is difficult to deny (and not disproven in the epilogue). Its success is impossible to ignore, but *Frozen* tried so hard to deny its own nostalgic influences that it faltered instantly.

The Duke of Weselton (not Weaseltown) has designs on taking over Arendelle, and is a visual homage to the King and Grand Duke characters from Cinderella (1950).

It's been five years since the *Los Angeles Times* pronounced that Disney was done with princess movies after *Tangled*. Since then, we've gotten *Frozen*, as well as live-action retellings of *Cinderella* and *Sleeping Beauty* that modernize the core concept of these iconic myths while staying true to the old-fashioned storytelling that defined the Disney versions.[37] Next year, Disney will release another film from the directors of *The Princess and the Frog*, the same film that inspired Ed Catmull to suggest his animation studio was finished with the subgenre. That film, *Moana*, focuses on a young woman who is the daughter of a Polynesian chief, and it will apparently be a musical. It's easy to suggest that *Frozen* is what inspired Disney to return to the woman-centric fairy tale, but that film's development suggests that the studio was never truly ready to give up on the format; they just needed to redefine how they sold *Frozen*, presuming incorrectly that female-driven films are box office poison.[38]

The decades of examples from Walt Disney Animation Studios are themselves a reminder that Catmull's claim that they were moving on from princess films was false. They are a living embodiment of the repeated mantra from P. T. Anderson's *Mag-*

nolia: "The book says, we might be through with the past, but the past ain't through with us." To move on from princess movies is to suggest that the only way to deal with the past is to ignore it. The quartet of films from Disney Animation in the early 2010s suggests the exact opposite: to deal with the past appropriately is to embrace it. The films aren't universally full of creative highs, but their best moments or performances reflect a sincerity instead of a snobbish dismissal of the long road of success Disney has had over the years. The last great period of Disney animation, the Renaissance of the nineties, didn't lack for awareness of the past, but was not so steeped in nostalgia to lack an identity of its own. With hope, the future for Disney animation holds a similar fate: placing one foot in the past instead of two, allowing nostalgia to exist without overwhelming audiences.

CONCLUSION

Twenty fifteen marks the twentieth anniversary of *Toy Story*, one of the most important films of the Western world; it can be placed alongside such landmarks as *The Great Train Robbery*, *The Birth of a Nation*, *Citizen Kane*, and *Star Wars*, because it was the first of its kind. Its existence is a flashpoint of modern film-making, a combination of cutting-edge technology and familiar tropes that resulted in something singular. In the intervening decades, the competition has tried to echo Pixar's innovative style with varying results. The undercurrent to so many films that exist as either a response to or replication of *Toy Story* is undeniably nostalgia-driven. The clever *The Lego Movie*, in the climactic twist revealing that the whole affair is the product of a kid responding negatively to his dad's draconian rules, grounds itself in the same playtime mentality defined by Andy's wild leaps of imagination. Even Pixar's most recent film, *Inside Out*, mourns the loss of childhood through its thorny and honest depiction of an eleven-year-old girl growing up quickly as she and her parents move cross-country.

There's a fundamental difference between how Pixar (and Walt Disney Animation Studios and DreamWorks Animation) processes nostalgia versus storytelling standbys. The act of telling stories with recognizable elements is as old as time itself. But the act of using our memories (or the memories of a presumed target audience) as a foundational element of a story, if not the key factor in engendering emotional reactions, has

become creatively necessary to the current generation of film-makers. Our childhood memories are the basis for countless films; the hazy and wistful longing in the *Toy Story* trilogy, *Cars*, *Up*, *Monsters University*, and more is equivalent to how shows like *Happy Days* used the recent past as a kind of idyll for which to long. The 1950s weren't as safe and clean as *Happy Days* suggested, but the all-encompassing bubble the show created, a comfortable, blissful image of what the past *might* have looked like, helped it become popular.

When pushed by Al McWhiggin, the toy fixer tells him, as if stating Pixar's mission: "You can't rush art!"

The bubble effect is inextricably tied to Disney's appeal. Their theme parks are expressly designed to incur nostalgia, not just for specific characters, but for a period lost in time. Main Street, USA, doesn't reflect the world at the turn of the twenieth century. What it creates is a desire for the ideal instead of reality. The same is true of Pixar's films, especially the *Toy Story* franchise. Our childhoods weren't the same as Andy's, but his world is so easy to get lost in precisely because we wish it was ours.

The impact of *Toy Story* in particular is so wide-ranging that its total effects can't yet be detailed. Thanks in part to the film, hand-drawn animation at American movie studios is essentially dead. Only eighteen months before *Toy Story*'s release, the traditional format hit an impossible peak: a few years after *Beauty and the Beast* became the first animated film to get nominated for Best Picture at the Oscars, *The Lion King* became the highest-grossing animated film ever made. (Even now, domestically, *The Lion King* is Disney's biggest success.) By the end of 1995, hand-drawn dominance was over; today, films that harbor nostalgia toward the Disney Renaissance or Golden Age are computer-animated. Disney can't help but pay homage to *Snow White and the Seven Dwarfs*, though not by hand. Walt Disney Animation Studios' most recent films (including 2014's *Big Hero 6*) offer a mildly positive outlook, even if it's one that remains beholden to films of the previous generation.

Even if hand-drawn feature animation makes a comeback, there's no turning back what *Toy Story* inspired. We now live in a vicious cycle of popular culture, wherein characters that defined the childhoods of generation X-ers and millennials are regurgitated in the hopes of raking in more money before those characters are regurgitated yet again.[1] Not all films borne of nostalgia are failures, but most are weighed down by whatever responsibilities their creators feel toward the fans of the world they've inherited. Fewer still are interested in being more than what they're based on.

The industry saw *Toy Story* and Pixar's burgeoning success, but did not pay attention. "You can't rush art!" is the brusque reply the elderly toy cleaner offers to Al in *Toy Story 2* when time is short for Woody to be fixed.[2] Pixar's first few films were not automatically synonymous with the "work of art" plaudit; now, we all but demand their films to enter rarefied air in the first act. As *Toy Story*'s influence expands, its qualitative importance becomes harder to ignore; like *Citizen Kane*, it stands apart from what it caused because the amount of care afforded to it

is unsurpassed. Pixar's other nostalgic efforts have not been as universally beloved, but by tapping into a modern generation's self-reflexive neuroses, even *Cars* speaks to an awareness of what moving on from the past means once we become introspective.

In a brief montage after the prologue in Toy Story 3 (2010), we see a few of Andy Davis's various misadventures with his toys, some as simple as attending his sister's birthday party.

In twenty years, no film has replicated the wonder and excitement evoked by the first *Toy Story*, precisely because many consciously *try* to replicate *Toy Story*. Even Disney is unable to avoid such repetition, as is obvious in the opening act of *Wreck-It Ralph*. Pixar's other great films—*The Incredibles* and *WALL-E*, among others—happen to be computer-animated, but they work because of the instinctive maturity on display within their seemingly ridiculous concepts. *Toy Story* may not have been so original that its connections weren't obvious, but it *felt* original in ways that few competitors have. *Toy Story* changed the cinematic landscape in 1995; whatever changes to Western cinema may come, they'll have to be drastic to be similarly impactful.

The major similarity among the *Toy Story* franchise and all comers is simple: here, childhood is infinite. It endures beyond one bedroom. Andy's toys gain a vicarious sense of humanity through him. When Buzz Lightyear shook his head subtly in despair, his arm cleaved from his body after an attempt at flight; when Jessie stared bleakly through a cardboard box on the side of a road; and when Woody gripped onto his friends' hands, acknowledging his mortality as he descended to the depths of a fiery pit, these toys became twenty-first-century Pinocchios. Woody and company never plead blatantly to be real; when they're in Andy's hands, their own Blue Fairy, they *are* real. However Pixar and Walt Disney Animation Studios proceed, even their better recent films like *Big Hero 6* and *Brave* can't approach the same highs as the *Toy Story* franchise, because the reality of its world is inescapable and almost wholly singular.

This series is as much about the nature and force of childhood as it is about the untenable bond between a child and his toy. (Recent Disney and Pixar films try to add characters and worlds to modern childhood; the *Toy Story* films, though, *depict* modern childhood.) By now, "You've Got a Friend in Me" is connected to the friendly rivalry between Woody and Buzz; however, it's telling that its first usage is during *Toy Story*'s opening credits, when Andy bounces around his living room with Woody. This friendship is dealt with more subtly because the filmmakers are smart enough to see our best selves in Andy and our worst selves in Sid, Al, and Lotso. The *Toy Story* films are rooted in a technological breakthrough that could have dated them; instead, this trilogy stands as one of the most timeless accomplishments in all cinema.

NOTES

Toy Story and *Cars*

1. Charles Solomon, *The Toy Story Films: An Animated Journey* (White Plains, NY: Disney Editions, 2012), 43.
2. This was almost literally the case, as the employee's desk was at one time located in a hallway of the company's cramped quarters, alongside a few colleagues.
3. David A. Price, *The Pixar Touch: The Making of a Company* (New York, NY: Alfred A. Knopf, 2008), 102.
4. The only notable exception in the United States is Laika Animation, which works in stop-motion.
5. *The Pixar Story*, directed by Leslie Iwerks (2007; Burbank, CA: Walt Disney Studios Home Entertainment, 2007), DVD.
6. David A. Price, *The Pixar Touch: The Making of a Company* (New York, NY: Alfred A. Knopf, 2008), 125.
7. Charles Solomon, *The Toy Story Films: An Animated Journey* (White Plains, NY: Disney Editions, 2012), 45.
8. David A. Price, *The Pixar Touch: The Making of a Company* (New York, NY: Alfred A. Knopf, 2008), 128.
9. The Blue Parrot, "Ruminations," *The Blue Parrot*, February 2, 2007, http://www.theblueparrot.info/wabacmachine/ The_Blue_Parrots_perch/Entries/2007/2/ 2_John_Lasseter_does_AM_Radio,_too.html.
10. The latter wound up with a small role in the *Cars* franchise as the sheriff of Radiator Springs.

11. Either way, the joke goes by so quickly that it barely makes an impact.

12. He'd also been willing to let Pixar's contract lapse at one point, having grown famously displeased with the studio. He once crowed to investors that he was sure they'd finally made a film that would flop with audiences and critics. That film was *Finding Nemo*.

13. Jeff Labrecque, "Larry the Cable Guy on Mater backlash: 'As long as John Lasseter's laughing and smiling and thinking it's funny, I'm good,'" *Entertainment Weekly*, October 31, 2011, http://www.ew.com/article/2011/10/31/cars-2-dvd-larry-the-cable-guy. Casting a self-pronounced redneck comedian isn't unique to *Cars*, either; Jim Varney, best known as Ernest P. Worrell, was the voice of Slinky Dog in the first two *Toy Story* films before passing away in 2001.

14. The chief example is Randy Newman's score quickly incorporating a riff on John Williams's theme from *Raiders of the Lost Ark*, as Buzz outruns a boulderlike globe that's nearly about to run him off Andy's desk.

15. Before the film ends, we also get to hear Jay Leno as Jay Limo, and Jeremy Piven providing the voice of Lightning's fast-talking, acerbic Hollywood agent, *à la* his character on the HBO show *Entourage*.

16. We should be grateful that Pixar avoided another visually unappealing incident like the lumpy Billy, the anointed nickname given by the animators to the baby in *Tin Toy*.

17. Mark Harris, "The Birdcage: How Hollywood's Toxic (and Worsening) Addiction to Franchises Changed Movies Forever in 2014," *Grantland*, December 16, 2014, http://grantland.com/features/2014-hollywood-blockbusters-franchises-box-office.

18. Even in the *Toy Story 3* teaser, his presentation of the title is depicted as cool and snazzy, whereas Woody's is handmade, rickety, and forgettable.

19. As Mark Harris noted at Grantland in 2014, the number of

franchises and comic book movies from 2015 to 2020 reach well beyond one hundred and will grow in time.

20. It's also, coincidentally, Pixar's longest film to date, at 116 minutes.

21. There was a time when he wasn't going to co-direct *Cars 2*, before production issues forced him to take a more public role in the project. However, as of this writing, he's slated to direct a recently announced fourth *Toy Story* film.

22. This is one of the more pointless and ill-advised gags in the picture.

23. It's unfortunately fruitless to wonder what kind of work a vehicular attorney does, as the world of this film was devised with a headlong ignorance of logic.

24. As laid-back as *Cars* is, it's incredibly daring to depict Lightning literally dropping his mechanical jaw at the sight of the landscape surrounding Radiator Springs. Having a character be so impressed at how the world in which he exists looks is equivalent to the animators patting themselves on the backs, albeit deservedly.

Toy Story 2 and *Up*

1. Caroline Siede, "10 of 14 Pixar Films Fail the Bechdel Test," *The AV Club*, November 3, 2014, http://www.avclub.com/article/thought-provoking-animation-about-how-pixar-films—211352. In the interest of disclosure, the *AV Club* piece also cites an article I wrote regarding Pixar's lack of racially diverse characters or casting.

2. Josh Spiegel, "The Pixar Perspective on Race," *The Pixar Times*, April 22, 2014, http://pixartimes.com/2014/04/22/the-pixar-perspective-on-race.

3. Charles Solomon, *The Toy Story Films: An Animated Journey* (White Plains, NY: Disney Editions, 2012), 87.

4. Even the late Steve Jobs, when appealed to by the co-

director of the sequel and eventual director of *Toy Story 3*, Lee Unkrich, couldn't provide any relief, because of the various merchandising entities involved in promoting the film.

5. *The Good Dinosaur*, Pixar's newest film, has had various production issues from scheduling delays to replaced directors, both of which have portended the worst to some, even though many Pixar films—and many animated films overall—go through such shifts regularly. Here is one of the few, and unfortunate, ways that people treat live-action and animated films similarly.

6. We can only speculate, but if there had been ten Best Picture nominees in 1999, as there were in 2010, it's not hard to imagine *Toy Story 2* being among them.

7. A more melodramatic, but no less powerful, scene of similar emotional weight occurred in Steven Spielberg's *AI*, which trumpets its connection to *Pinocchio*, while the *Toy Story* films are quieter about the parallels.

8. That Andy comes awfully close to considering the former option mostly speaks to the fact that kids going to college in the twenty-first century feel less self-conscious about bringing toys with them into the real world than those of pre–*Toy Story* generations.

9. There is something oddly gratifying about the revelation here that he's a toy based on a character who once achieved the same level of fame as Buzz Lightyear does in the 1990s.

10. By this point, Stinky Pete has been permanently deposited, in a darkly funny punchline, into the backpack of a girl who defaces her Barbie dolls in the name of "art." The Tokyo museum where the toys were originally headed would thus refuse to pay Al McWhiggin for the shipment, because the entire collection—namely Woody—isn't present.

11. Jeremy Smith, "Mr. Beaks Goes *Up* with Pixar's Pete Docter!," *Ain't It Cool News*, July 27, 2008, http://www.aintitcool.com/node/37668.

12. The third film echoes this, but amplifies the detrimental nature of not moving on and instead living out those glory days ad infinitum.
13. Lisa Schwarzbaum, "Up," *Entertainment Weekly*, May 27, 2009, http://www.ew.com/article/2009/05/27/up.
14. Pixar wasn't actually new to incorporating blood in its films: Dory gets a nosebleed in *Finding Nemo*, and Mr. Incredible gets mildly wounded by the Omnidroid in *The Incredibles*.
15. That said, the explosion, descending on the Parr household as a massive fireball that decimates everything in its path, doesn't leave behind any sort of gory aftermath.
16. Sheila O'Malley, " 'Talk About the Movie': *A Bug's Life* and *Up*," *The House Next Door*, October 4, 2009, http://www.slantmagazine.com/house/article/talk-about-the-movie-a-bugs-life-and-up.
17. Roger Ebert, "*Up*," *RogerEbert.com*, May 27, 2009, http://www.rogerebert.com/reviews/up-2009.
18. It's Muntz who looks for some level of fame, *à la* Stinky Pete being immortalized as part of the *Woody's Roundup* gang.
19. Oswald was owned by another studio until the Walt Disney Company essentially traded sportscaster Al Michaels to NBC Universal for the rights to Oswald in 2006.
20. His paranoia inspires him to presume that they did so simply to rob Muntz of his glory, but it seems likely that they were unaware of Muntz or his history.
21. Arguably, this is reversed in *The Incredibles*, where our hero is someone else's idol, but is no less dispiriting.
22. The aftereffects are explicitly felt in the first act of *Toy Story 3*, where the character all but hyperventilates—if such a thing is possible for an inanimate object—at the thought of being thrown into the attic with the other toys when Andy moves to college.
23. The way in which Russell is portrayed, both as Asian

American and as a child of divorce, is done so matter-of-factly that it reaches a level of unexpected poetry. Few other filmmakers are as confident as Docter is here.

Toy Story 3 and *Monsters University*

1. Andrew Stanton, for example, stated on the film's commentary that his own insecurities as a young father inspired him to write and direct *Finding Nemo*.
2. For just over four years, everyone presumed that *Toy Story 3* was the definitive conclusion of the franchise, leaving aside any shorts and TV specials. However, near the end of 2014, John Lasseter announced that he would direct his first film in nearly a decade, *Toy Story 4*, slated to open in the summer of 2018.
3. The other film is *Cars 2*, arguably Pixar's weakest and, for the doomsayers, a sign of things to come.
4. Mike's failure is more obvious from the outset; we may wonder initially if Andy might really bring his toys, or a few of them, to his dorm room, but anyone familiar with *Monsters, Inc.* inherently *knows* that Mike will never be scary.
5. This goes down to even the littlest details, like a reference or two to Unkrich's self-professed favorite film, Stanley Kubrick's *The Shining*, such as the infamous room 237 in Kubrick's version of the Overlook Hotel appearing in license plates and online handles.
6. If there is any whiff of repetition in the film, it's in the others toys' quickness to doubt him—though how Woody would know the potential downside of a daycare facility is a mystery—and their subsequent guilt at realizing he was correct the whole time.
7. The fervor Rex, specifically, exhibits at the thought of being held again is nearly religious.
8. Bonnie, depicted as being a couple years younger than Andy

was in the 1995 film, is no less imaginative than the toys' original owner, but her wired attitude while playing feels somewhat different from, and more delightful than, Andy's Western pastiche.

9. Even the toy soldiers who wisely bail out of the teenager's bedroom in the opening act don't appear to touch down on solid ground until the end credits, right in front of the reborn Sunnyside.

10. The most familiar comparison would be to Michael Apted's *Up* series, but the world of cinematic fiction has few equal connections.

11. Myles McNutt, "Rumination vs. Revelation: Pixar, the Remarkable, and *Toy Story 3*," *Cultural Learnings*, June 18, 2010, http://cultural-learnings.com/2010/06/18/rumination-vs-revelation-pixar-the-remarkable-and-toy-story-3.

12. It's interesting to note that Woody's nightmare would make more sense appearing in *Toy Story 3*; he has to be convinced by Buzz and the gang to come back to Andy instead of the Tokyo museum.

13. Though it's foolhardy to read anything concrete into the various Easter eggs Pixar animators leave in their films, one could argue that Lotso, since he makes a brief cameo appearance in a child's bedroom during an early montage in *Up*, had more staying power as a toy than Woody ever did.

14. A more cynical reading of this is that the filmmakers may appreciate that they can't replicate the brilliance of films like *The Incredibles* and *WALL-E*, among others, so they should be content with whatever they *can* make.

15. Frankly, relative to the onslaught of popular culture that preys on its collective audience's memories, the very decision to comment on moving on is itself a success. Countless comic book movies, the *Transformers* franchise, and the like have a minimal interest in anything beyond meeting the surface-level expectations of their diehard fans.

16. Scott Mendelson, "15 Years of DreamWorks Animation and Its Legacy," *Forbes Media and Entertainment*, October 2, 2013, http://www.forbes.com/sites/scottmendelson/2013/10/02/15-years-of-dreamworks-animation-and-its-complicated-legacy. Arguably, the issue of competition among animation units didn't become nearly as threatening to the overall Disney legacy until Michael Eisner and future DreamWorks honcho Jeffrey Katzenberg jump-started the animation department in the 1980s.

17. Matt Singer, "The Expectations Game and *Cars 2*," *IFC Fix*, June 27, 2011, http://www.ifc.com/fix/2011/06/the-expectations-game-and-cars.

18. Matt Singer, "Why Can't Pixar Make Sequels?," *Criticwire*, April 2, 2013, http://blogs.indiewire.com/criticwire/why-cant-pixar-make-sequels.

19. Calum Marsh, "The Pixar Myth: How *Finding Dory* Proves that Money Always Matters," *Film.com*, April 3, 2013, http://www.film.com/movies/finding-dory-pixar-sequels.

20. Creativity aside, *Monsters University* did very well at the box office, which is an all-but-assured truth of every Pixar film, none of which have grossed under $160 million domestically.

21. Adam B. Vary, "Pixar Chief: Studio to Scale Back Sequels, Aim for One Original Film a Year," *Buzzfeed*, June 27, 2013, http://www.buzzfeed.com/adambvary/pixar-chief-studio-to-scale-back-sequels-aim-for-one-origina.

22. Chris Bell, "Pixar's Ed Catmull: Interview," *The Telegraph*, April 5, 2014, http://www.telegraph.co.uk/culture/pixar/10719241/Pixars-Ed-Catmull-interview.html.

23. Though the film doesn't spend too much time nudging the audience to remember jokes from the 2001 effort, its few attempts to do so are predictable instead of surprising and funny, as when the nasally Roz makes a third-act cameo.

24. Mike and Sulley do manage to work at Monsters, Inc. by the end.

25. Arguably, they're at .750 now.
26. DreamWorks Animation has, at certain points in its history, released four sequels over a period of two years.
27. "Pixar," *Box Office Mojo*, accessed February 26, 2015, http://boxofficemojo.com/franchises/chart/?id=pixar.htm&adjust_yr=1&p=.htm.
28. Perhaps it would have been of equal risk to have a sequel take place in the future, where Mike and Sulley encounter an older, wiser Boo—with an actual name and the ability to form sentences, to boot.

Disney Animation in the 2010s

1. Dawn C. Chmielewski and Claudia Eller, "Disney Animation Is Closing the Book on Fairy Tales," *Los Angeles Times*, November 21, 2010, http://articles.latimes.com/2010/nov/21/entertainment/la-et-1121-tangled-20101121.
2. Catmull has since said, in his book *Creativity, Inc.*, that Disney's marketing team warned bigwigs that a film with the word "princess" in the title was box-office poison, but the animation department was convinced that the film's high quality and animation style would be enough to push past any skepticism, something he dubs in the book as "our own version of a stupid pill." Ed Catmull, with Amy Wallace, *Creativity, Inc.: Overcoming the Unseen Forces that Stand in the Way of True Inspiration* (New York, NY: Random House, 2014), 268.
3. Keane would move on from Disney in early 2012.
4. Dawn C. Chmielewski and Claudia Eller, "Disney Restyles 'Rapunzel' to Appeal to Boys," *Los Angeles Times*, March 9, 2010, http://articles.latimes.com/2010/mar/09/business/la-fi-ct-disney9-2010mar09. Disney's arguments aside, the likelier reason why the film was only a moderate success is

poor timing; opening opposite the juggernaut known as *Avatar* was just bad luck.

5. Though *Frozen* is an extremely loose adaptation, it's hard not to imagine that Disney felt they shouldn't call the film *The Snow Queen* for similar reasons. It's also worth pointing out that, aside from *The Princess and the Frog*, no other Disney animated feature in the canon includes the word "princess." Even if *Tangled* had been called *Rapunzel*, the word "princess" would only be inferred.

6. Rebecca-Anne C. Do Rozario, "The Princess and the Magic Kingdom: Beyond Nostalgia, the Function of the Disney Princess," *Women's Studies in Communication* 27, no. 1 (Spring 2004): 42.

7. This decision was perhaps made well before the title change from *Rapunzel* to *Tangled*; in fact, it may be the only creative reason to justify said shift.

8. Flynn's opening narration literally clarifies that he's not even telling his own story, but Rapunzel's, an odd grace note in a film so split between characters.

9. Paul Liberatore, " 'Brave' Creator Blasts Disney for 'Blatant Sexism' in Princess Makeover," *Marin Independent Journal*, May 11, 2013, http://www.marinij.com/general-news/20130511/brave-creator-blasts-disney-for-blatant-sexism-in-princess-makeover. This has extended to Pixar in recent years, as Princess Merida from *Brave*, an arguably fiercer and more independent young woman, was subsumed in the Disney princess toy line to a point where her redesign was criticized by the film's original director, Brenda Chapman, who said, "I think it's atrocious what they have done to Merida . . . [she] was created to . . . give young girls a better, stronger role model, a more attainable role model, something of substance, not just a pretty face that waits around for romance." Once these characters are out of their creators' control, they revert troublingly back to wince-inducing stereotypes, designed to look unnaturally thin and

superficially pretty even when they originally looked vastly different.

10. The climax also compartmentalizes the entirety of *Beauty and the Beast* into a few minutes: the princess offers her own life to save someone she loves to placate a terrifying antagonist; once her true love sacrifices himself for her, it's her grief and emotion that brings him back from the brink.

11. Relative not only to Pixar and Disney films, but most modern animated films such as those from the independent studio Laika, this is a pittance. *Wreck-It Ralph* and *Frozen* had budgets north of $160 million, which is fairly common.

12. A series of three 1960s shorts strung together to be a feature, this was designed to make more money than it cost for the string.

13. Even *Dumbo*, which is a minute longer and was made for less money than the other features in Disney's first Golden Age, has a clear enough struggle from the early going for the main character to surmount.

14. The great irony: in choosing to counterprogram against a big new blockbuster, Disney signed the film's box-office death warrant by opening it on the same day as a tiny film called *Harry Potter and the Deathly Hallows, Part 2*. Thus, as of this writing, Disney hand-drawn animated features are no more. The end of an era indeed.

15. This is another *Toy Story*–esque situation, and the prototype for that franchise, in a sense.

16. The idea that Christopher goes to school is, in itself, a sign of the changing times; soon enough, he'll be too old to play with these toys.

17. A. A. Milne, *The House at Pooh Corner* (London, England: E. P. Dutton, 1928), 180.

18. "Christopher Robin's Real-Life Happy Ending," *The Telegraph*, October 19, 1998, http://www.telegraph.co.uk/culture/4715991/Christopher-Robins-real-life-happy-ending.html. It's worth noting here that the real-life

Christopher Robin, A. A. Milne's son, was not quite so pleased to have become a symbol for children who suffer as much from Peter Pan syndrome. He once said, in response to a question about whether he was sad to no longer own the toys that served as inspiration for Milne's characters, "Not really . . . I like to have around me the things I like today, not the things I once liked many years ago."

19. Liam Heneghan, "The Ecology of Pooh," *Aeon*, March 5, 2013, http://aeon.co/magazine/psychology/liam-heneghan-ecology-childhood.

20. Even here, the *Toy Story* series came first, with the *Small Fry* short. This 2011 *Toy Story* short featured a support group for discarded fast-food toys. The major difference: all but one of the toys weren't based on real characters. (The exception is a reference to the barely remembered live-action Disney film *Condorman*.)

21. There's also something extremely discomforting about Ralph's arc centering on his eventual decision to accept the credo spouted by his fellow villains in the support group, that he has to accept his place and not try to change his circumstances. The idea that it would be a terrible thing for him to *not* maintain his current role is never denied; because Ralph wants to be thought of as decent, chaos reigns.

22. If all of the games in the arcade were as similarly long in the tooth, in terms of production and character design, as *Fix-It Felix Jr.*, the film's era would be less easy to pick apart. But both *Hero's Duty* and *Sugar Rush* suggest the present day.

23. It's odd, to be sure, that one of the characters who asks Ralph if he's "going Turbo" is King Candy, i.e., Turbo himself.

24. When we first learn of the character's backstory, it's presumed that he died, as it were.

25. One poster literally buries all of the human characters in snow.

26. The nonsensical lyric, "Don't know if I'm elated or gassy / But I'm somewhere in that zone" is as anachronistic to the indefinable but clearly old-school setting as the title of the song in which that lyric appears, "For the First Time in Forever."

27. Some are vastly better than others at this; the brilliant *Arrested Development* is the epitome of hyper-aware pop culture, and ends up being referenced multiple times in *Frozen*, from its memorable chicken dance echoed in the Duke of Weselton's rhythmic style to the " 'We finish each other's—' / '—Sandwiches!' " lyric in "For the First Time in Forever."

28. The brief image of the capsizing ship viewed from a distance, aboard which are our heroines' parents, is the film's best, communicating the resulting heartbreak quickly and definitively.

29. Jim Hill, "Countdown to Disney *Frozen*: How One Simple Suggestion Broke the Ice on the Snow Queen's Decades-Long Story Problems," *Jim Hill Media*, October 18, 2013, http://jimhillmedia.com/editor_in_chief1/b/jim_hill/archive/2013/10/18/countdown-to-disney-quot-frozen-quot-how-one-simple-suggestion-broke-the-ice-on-the-quot-snow-queen-quot-s-decades-long-story-problems.aspx#.UmbFXxZPrTQ.

30. Prince Hans is a selfish, power-hungry young man who plans to let his would-be bride, Anna, die while Elsa rots in prison, thus manipulating his way to the throne as King of Arendelle.

31. There are, predictably, many male characters in *Brave*, but all of them are presented as outrageous and farcical caricatures of macho masculinity.

32. Granted, a cynic could look at that example as a case of someone succumbing to Stockholm syndrome.

33. By the end of the song, they've created a makeshift wedding ceremony for the couple.

34. Cassandra Stover, "Damsels and Heroines: The Conundrum of the Post-Feminist Disney Princess," *Women's Studies in Communication* 2, no. 1 (2013): 4.

35. The conversations Anna and Hans are meant to have, bringing them closer together during the ball, are dispensed with in a mostly wordless montage.

36. Olaf, the other major character, is somewhat similar to Timon and Pumbaa from *The Lion King*, a comic-relief character who doesn't figure into the story as a whole.

37. Disney's new trend is reviving pretty much all of its animated films for live-action retellings. As of this writing, *Dumbo*, *The Jungle Book*, and *Winnie the Pooh* are all getting the live-action treatment.

38. *Frozen, The Hunger Games, Bridesmaids*, and *Fifty Shades of Grey* are, quality aside, excellent examples of why that presumption is wildly inaccurate.

Conclusion

1. An extreme example is *Spider-Man*, with multiple cinematic iterations in just over fifteen years.

2. It's ironic to hear that line in a film whose production was the definition of *rushed*.

ABOUT THE AUTHOR

Josh Spiegel is the reviews editor for *Movie Mezzanine*, and co-hosts the Disney movie podcast *Mousterpiece Cinema*, which he created in June 2011, with Gabe Bucsko. He has been a member of the Online Film Critics Society since 2013. He was previously the chief film critic and film editor of *Sound on Sight*. He's also a columnist for *The Pixar Times* and *The Disney Times*. He lives in Arizona with his wife, son, and far too many cats.

CPSIA information can be obtained at www.ICGtesting.com
Printed in the USA
BVOW06s1617301115

428864BV00012B/188/P